# IMAGES of America
# THE WHITE HORSE PIKE

Jill Maser

ARCADIA

Copyright © 2005 by Jill Maser
ISBN 0-7385-3910-4

Published by Arcadia Publishing
Charleston SC, Chicago IL, Portsmouth NH, San Francisco CA

Printed in Great Britain

Library of Congress Catalog Card Number: 2005930117

For all general information contact Arcadia Publishing at:
Telephone 843-853-2070
Fax 843-853-0044
E-mail sales@arcadiapublishing.com
For customer service and orders:
Toll-Free 1-888-313-2665

Visit us on the internet at http://www.arcadiapublishing.com

IMAGES
*of America*

# THE WHITE
# HORSE PIKE

# Contents

| | | |
|---|---|---|
| Acknowledgments | | 6 |
| Introduction | | 7 |
| 1. | The Birth of Atlantic City | 9 |
| 2. | Rails and the Development of White Horse Pike Towns | 13 |
| 3. | The Automobile and the Bridge | 45 |
| 4. | Development along the Pike | 69 |
| 5. | Atlantic City a Generation Later | 117 |
| 6. | What the Future Holds | 127 |
| Bibliography | | 128 |

# ACKNOWLEDGMENTS

*As I went to bed a few Saturday nights ago, it entered my head all of a sudden, decidedly yet quietly, that if the coming morn was fine, I would take a trip across Jersey by the Camden and Atlantic Railroad through to the sea.*

—Walt Whitman, 1878.
(Reprinted courtesy the *Courier-Post*, Cherry Hill.)

I have often entertained similar thoughts, although I travel on New Jersey Transit, and thus this book was born.

Research is one of the perks of writing. I am very much at home among volumes of every shape and size that make up library collections, and when the libraries close, I find new worlds to explore on the Internet. But no education is complete without personal contact. *The White Horse Pike* would not have come together without the expertise and generosity of the following individuals: Joseph Adolph; Robert Benner, Atlantic Cape Community College; Helen Bradley, Magnolia Historical Society; Peter Childs, Collingswood Library; Phil Cohen, http://www.DVRBS.com; Joe Emerson; Barbara Gilbert, Borough of Berlin; Peter Hamilton, West Jersey History Project; Dennis Harkins, Magnolia Historical Society; James F. Henry; Lou Hochman, the *Record Breeze*; Robert J. Hunter, Haddon Heights Library; Ron Karifin, the *Courier-Post*; Bruce Long; Robert L. Long; Richard A. Martino, Modjeski and Masters; Mark W. Maxwell, Egg Harbor City Historical Society; Louise Palmisano; John Polillo, Twin Brothers Productions; Kevin Riordan, the *Courier-Post*; Robert Ruffolo, Princeton Antiques; Mike Schwartz, the *Courier-Post*; Stuart Shinske, the *Courier-Post*; Ann Tomasello; Bob Tomasello; Mike Williams, Delaware River Port Authority; Jack Witzig, Haddon Heights Historical Society.

My heartfelt thanks go out to all of these kind people, and to my friends, whose ongoing support is very much appreciated.

# INTRODUCTION

From footpath to stagecoach route, from rutted dirt road to four-lane highway, the White Horse Pike may be one of the country's most storied roads.

The White Horse Pike has existed since the Leni-Lenape Indians first settled southern New Jersey. Their migratory route, a direct line from the Delaware River to the Atlantic coast, has served as a footpath, stagecoach route, toll road, and the pattern for two railroad lines. The Jersey Devil himself has been purported to travel the route. His best-documented appearances place him at points along the White Horse Pike during a two-week stretch in 1909. Today, the White Horse Pike remains a major highway serving commuters and vacationers between Philadelphia, Pennsylvania, and Atlantic City, New Jersey.

The Leni-Lenape developed footpaths from the Delaware River, along the tidal creeks, through the thick interior forest, and on to the Atlantic coast. During the planting season, they settled near the creeks and fished while their crops of maize, peas, and beans matured. After the harvest, they migrated inland, where the forest provided shelter and fuel. They continued on to the shore where they collected shells from which to fashion wampum.

The first European settlers saw the value of the footpaths, and as their traffic and modes of transportation developed, the pike saw its first improvements. Stagecoaches and other horse-drawn conveyances required a wider road. And while movement through the western part of the country was relatively smooth, once travelers crossed the watershed at Long-a-Coming (Berlin), the road became a boggy, sandy, wheel-sticking mess. Pine planks, cut from the abundant old growth in what is known as the Pine Barrens today, were laid across the route to allow for ready passage. The weather took its toll, and the route remained a rough ride for even the most seasoned travelers.

Poor travel conditions did not deter those seeking the respite found at the Atlantic shore. Summer in the city is never a pleasant experience. Citizens from Philadelphia and Camden braved the jolting multiple-day ride to cavort on the beaches along New Jersey's coast.

Dr. Jonathan Pitney of Absecon took note of the growing numbers of seaside visitors. He believed in the restorative powers of the ocean and envisioned a health resort along the coast where thousands would come to cure their ills. No rutted, planked road could move so many people. Pitney's answer was to be found on the rails. In February 1851, Pitney met with his friend Enoch Doughty and began to draft a charter to build a railroad from Camden to the Atlantic shore. Pitney and Doughty's influence, combined with the financial backing of glassmaking

mogul Samuel Richards, made for a smooth ride through the state railroad monopoly in Trenton. The first shares of Camden and Atlantic Railroad Company stock were sold in 1852, and the line celebrated its opening on July 1, 1854. Some 600 invited guests made the trip from river to shore that day along a route virtually parallel to the White Horse Pike in a mere two-and-a-half hours.

The birth of the Camden and Atlantic opened fierce competition among railroad companies. The narrow-gauge Philadelphia and Atlantic Railroad opened soon thereafter, and the Jersey shore developed as a tourist destination. Walt Whitman regularly rode the Philadelphia and Atlantic to his summer retreat in Laurel Springs, and in 1878, he traveled through to Atlantic City on the Camden and Atlantic. The Atlantic City of Whitman's era is a far cry from the city of today, as he described in his travelogue:

> I had a fine and bracing drive along the smooth sand (the carriage wheels hardly made a dent in it). The bright sun, the sparkling waves, the foam . . . a sail here and there in the distance . . . the vital, vast, monotonous sea all the fascination of simple uninterrupted space, shore, salt atmosphere . . . were the items of my drive. (Reprinted courtesy of the *Courier-Post*, Cherry Hill.)

New Jersey's population boomed with the large waves of European immigrants in the 1890s. Towns sprang up along the White Horse Pike and its surrounding rail lines. Fresh air and healthy living were touted as reasons to move out of Camden and into the suburbs of southern New Jersey. In addition, this south-central part of New Jersey proved to be fertile farmland. Tomatoes, cabbages, and fruits found markets in Camden and Philadelphia, not only for citizens, but for burgeoning new industrial markets such as the Campbell Soup Company.

The White Horse Pike grew again to accommodate the horse-drawn wagons laden with fresh Jersey produce. The number of trains running from river to shore increased. Ferries carried increasing numbers of passengers and tons of freight between Camden and Philadelphia. There was even serious talk about bridging the Delaware River to ease the stop-and-go methods of travel between the sister cities. But, as many major projects to be undertaken by a coalition of governments, plans for the bridge died.

Just as the railroads were reaching their peak, a number of inventors were perfecting their horseless carriages. Reaching speeds of eight miles per hour, these amazing steam- or gasoline-powered vehicles were able to travel existing roads. As competition among automakers grew fierce, prices dropped. The notion of jumping in the family auto and going wherever one wanted was enticing to a public just starting to shed its Victorian inhibitions. And thanks to Henry Ford's vision, automobiles became affordable for almost every American.

The increasing number of automobiles on the White Horse Pike, and the increasing speeds with which they traveled, called for yet another major improvement. Tight curves were eased. The roadway was widened to three broad lanes. And, in 1922 the entire route was paved in smooth concrete, making the White Horse Pike the longest concrete-paved highway in the world.

By 1924, one in seven Americans owned an automobile. Gas stations, auto repair shops, and general stores popped up amongst the fancy residences and stretches of farmland all along the pike to serve the ever-increasing number of travelers and commuters. The route was lighted in the late 1920s.

Uninterrupted travel and trade between Philadelphia and Camden could wait no longer. The Delaware River Bridge Joint Commission was formed, plans drawn up, and in 1926, the Delaware River Bridge (now the Ben Franklin Bridge) opened to traffic volume exceeding everyone's expectations.

The railroads' day had come and gone. Today, the White Horse Pike, a broad four-lane road for much of its route, remains a popular commuter roadway, center of commerce, and city-to-shore thoroughfare.

This volume features several towns along the route as well as the Ben Franklin Bridge. The reader will revisit Walt Whitman's impressions from 1878 and contrast them with scenes along the White Horse Pike in the years between World War I and World War II—the road's heyday.

# One

# THE BIRTH OF ATLANTIC CITY

The birth and development of Atlantic City is most likely the first of three phenomena contributing to the survival and popularity of the White Horse Pike.

In 1878, Walt Whitman, perhaps Camden's most famous citizen, journeyed to Atlantic City via the Camden and Atlantic Railroad, which followed nearly the same route as the White Horse Pike. His travelogue, "A Trip Through the Wilds of New Jersey," was printed in the *Camden Daily Post* on January 12, 1879.

The title of the article tells us much about the undeveloped state of southern New Jersey at the time. Perhaps most fascinating is what he observed upon arriving in Atlantic City.

> A flat, still sandy, still meadowy region (some of the old hummocks with their bard sedge, in tufts, still remaining) an island, but good hard roads and plenty of them, really pleasant streets, very little show of trees, shrubbery, etc., but in lieu of them a superb range of ocean beach miles and miles of it, for driving, walking, bathing.
>
> In front, as far as I could see, and right and left, plenty of beach, only broken by a few unpainted wooden houses. . . . How the main attraction and fascination are in the sea and shore! How the soul dwells on their simplicity, eternity, grimness, and absence of art! (Reprinted courtesy of the *Courier-Post*, Cherry Hill.)

The scene Whitman witnessed was not long to last. Development of the seaside resort was rampant, but pause now to enjoy the beauty that the poet experienced.

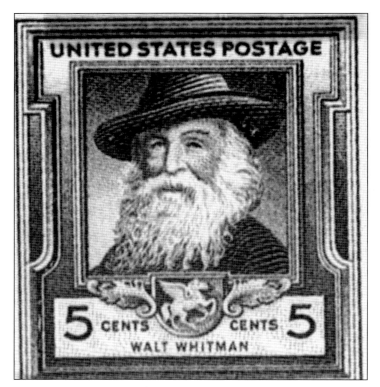

WALT WHITMAN POSTAGE STAMP, ISSUED 1940. Poet Walt Whitman moved to Camden in 1873 to nurse his dying mother. The "good gray poet" was himself in ill health, but his self-described partial paralysis did not keep him from traveling. His method of transportation was the train—a smooth and quick alternative to riding the rutted dirt pike in horse and carriage. (Courtesy James F. Henry.)

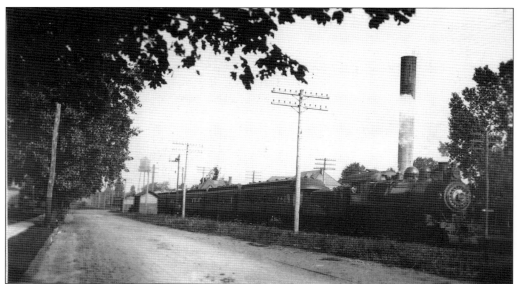

THE PHILADELPHIA AND ATLANTIC RAILROAD, EASTBOUND AT COLLINGSWOOD, C. 1930. The popularity of Atlantic City as a health resort and tourist attraction led to the building of competitive railroad lines. The Philadelphia and Atlantic, a narrow-gauge line, was completed in 1877 and ran just to the south of the White Horse Pike between East and West Atlantic Avenues. Competition and the growing popularity of the automobile led to financial difficulty for both railroads and, ultimately, to their demise. (Courtesy Collingswood Library.)

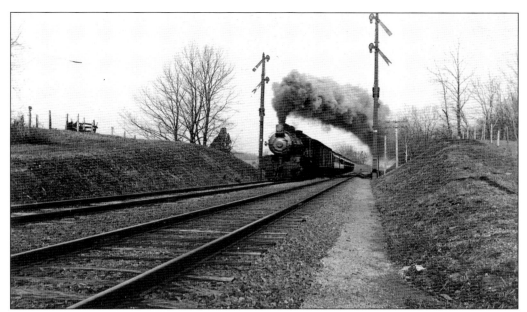

THE CAMDEN AND ATLANTIC RAILROAD, WESTBOUND AT ASHLAND, C. 1905. Laid out just to the north of the White Horse Pike, the Camden and Atlantic Railroad opened for business in 1854. First dismissed as the "railroad to nowhere," the Camden and Atlantic delivered 600 dignitaries on its maiden run and soon the two-and-a-half-hour ride transported thousands of visitors to the growing resort city. (Courtesy Collingswood Library.)

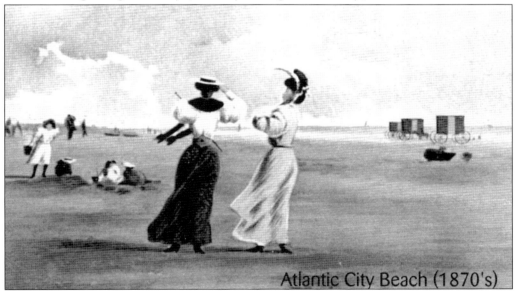

THE LURE OF ATLANTIC CITY, C. 1870. This postcard depicts the vista that Walt Whitman described in his 1879 travelogue. The brisk sea breeze and fresh salt air were just what the good Dr. Pitney ordered when he envisioned his health resort. Atlantic City did not remain undeveloped for long. Hotels and rooming houses were built to accommodate the growing number of travelers. The first amusement piers were constructed, extending out into the surf, in the 1880s, bringing a new wave of visitors to the Jersey Shore. (Author's collection.)

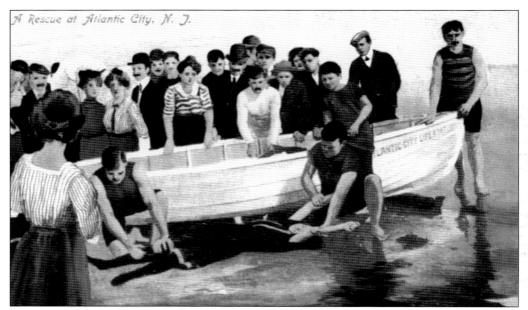

A BATHER IS RESCUED, C. 1882. Just a few years after Walt Whitman experienced Atlantic City's secluded beauty, the city's population ballooned to 27,000. The number of visitors required that the city begin to patrol its beaches. Bathing hours of 9:00 a.m. to 5:00 p.m. were posted and monitored by the Atlantic City Beach Patrol, formed in 1881. A total of 20 lifeguards were on duty in 1882 to keep bathers safe. (Author's collection.)

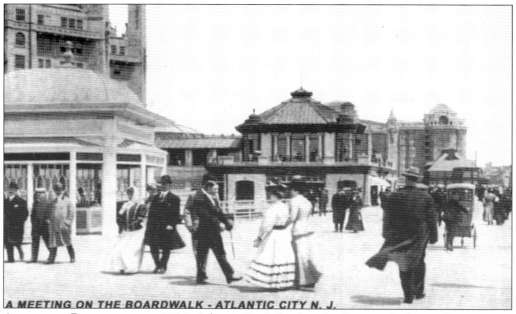

ALONG THE BOARDWALK, C. 1900. Atlantic City's first boardwalk, an eight-foot-wide temporary structure, was laid down in 1870 as a way of keeping sand from being tracked into the shorefront hotels and onto the trains. Around 1900, hundreds of hotels and boardinghouses, beer gardens, and even opera houses attracted vacationers. (Author's collection.)

# Two

# Rails and the Development of White Horse Pike Towns

Walt Whitman hints at the development to come to towns along the railroads and White Horse Pike in his 1878 travelogue:

> Some four or five miles south of Haddonfield we come to the handsome railroad station of Kirkwood. . . . Here is a beautiful broad pond or lake. . . . In summer the pond, with its young groves and adjacent handsome pavilion, forms a favorite destination for Philadelphia and Camden picnics.
> Five miles from Kirkwood we strike the thrifty town of Berlin (old name Long-a-Coming, which they had much better kept).
> We steam rapidly on to Hammonton, about thirty miles from Philadelphia (half way on the route) and the liveliest looking town on this part of the road.
> The whole route (at any rate from Haddonfield to the seashore) has been literally made and opened up to growth by the Camden and Atlantic railroad.
> We come to Egg Harbor City, settled about twenty-five years ago by the Germans, and now with quite a reputation for grape culture and wine-making scattered houses off in the brush in the distances. . . . (Reprinted courtesy of the *Courier-Post*, Cherry Hill.)

The images in this chapter depict scenes that Whitman and his fellow travelers may have encountered on their travels between Camden and Atlantic City.

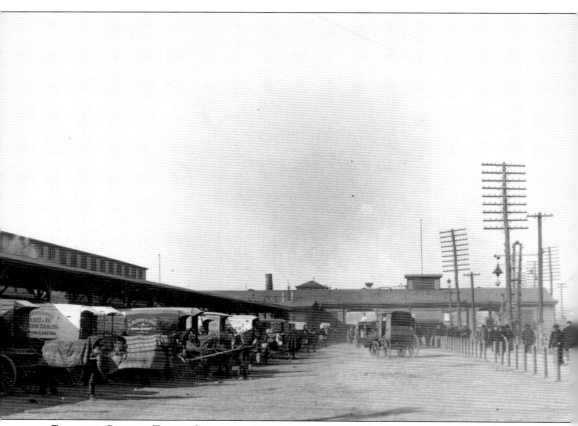

FEDERAL STREET FERRY STATION, CAMDEN, C. 1900. Ferries transported goods as well as people. The bulk of the tourist season was limited to the summer months. Railroads could not survive on tourist transport alone. Trains and horse-drawn wagons carried fresh produce, grains, timber, and glassware to be distributed in Camden or ferried to Philadelphia markets. (Courtesy Collingswood Public Library.)

MARKET STREET FERRY STATION AND DELAWARE RIVER, CAMDEN, C. 1900. This view depicts the bustling thoroughfare of the Delaware River in the era before automobiles, trucks, and aircraft. The shipping lanes and ferry ports did brisk business from the time the area was first settled until well into the 20th century. (Courtesy Collingswood Library.)

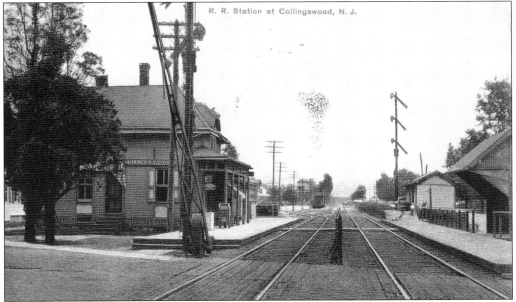

COLLINGSWOOD RAILROAD STATION, 1909. By the early 1900s, train travel had become commonplace for shore-bound tourists, but developing towns along the rail lines were attracting new citizens who commuted to their jobs in Camden and Philadelphia. Once farming communities, towns like Collingswood were attractive for their proximity to city centers and their fresh air and green spaces. (Courtesy Collingswood Library.)

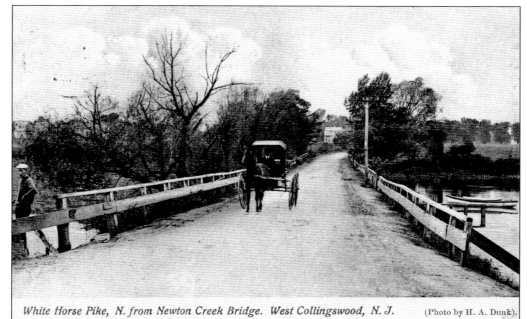

*White Horse Pike, N. from Newton Creek Bridge. West Collingswood, N. J.* (Photo by H. A. Dunk)

**WHITE HORSE PIKE, WEST COLLINGSWOOD, 1909.** This view looking north from the Newton Creek Bridge shows just one of the bucolic scenes awaiting travelers. The White Horse Pike, like the Leni-Lenape footpath before it, crossed or passed by many streams and lakes as it wound its way to the shore. The horse-drawn wagon soon had to share the road with newfangled automobiles. (Courtesy Collingswood Library.)

**PRINCE'S ICE WAGON, COLLINGSWOOD, 1872.** Before motorized trucks and vans, small businessmen delivered their wares by horse-drawn wagon. Mr. Prince, the iceman, probably did a healthy business in order to maintain two horses to pull his wagon to customers along the White Horse Pike towns. (Courtesy Collingswood Library.)

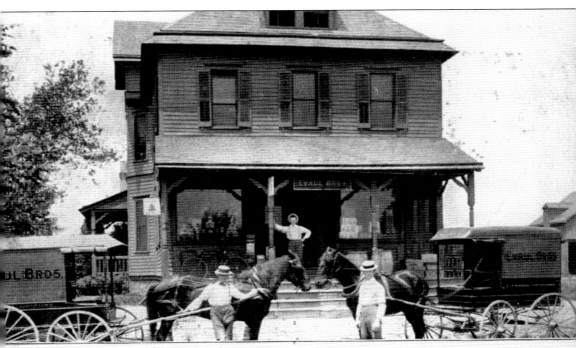

Evaul Bros., Haddon Heights, N. J., 1898

EVAUL BROTHERS STORE, HADDON HEIGHTS, 1898. General stores and other markets proliferated along the White Horse Pike as suburban towns developed. The stores were conveniently located for deliveries up and down the pike and were situated within a short walk of the town's train station. The Evaul brothers opened for business in 1898 at the corner of the White Horse Pike and Station Avenue, selling dry goods and housing the post office. Note the public telephone sign on the left side of the porch. (Courtesy Haddon Heights Library.)

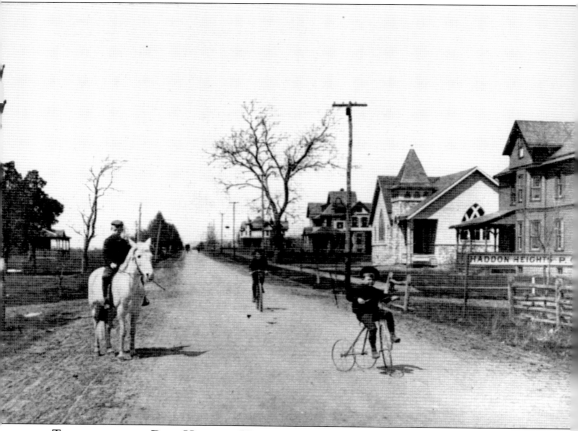

TRAFFIC OF THE DAY, HADDON HEIGHTS, C. 1900. This photograph of the White Horse Pike (Fifth Avenue) and Station Avenue, looking north to Camden, captures three modes of transportation: bicycle, horseback, and a horse-drawn wagon in the distance. The Haddon Heights Post Office sign stands outside Evaul Brothers store at the right. The First Baptist Church is the white building next to Evaul Brothers. (Courtesy Haddon Heights Library.)

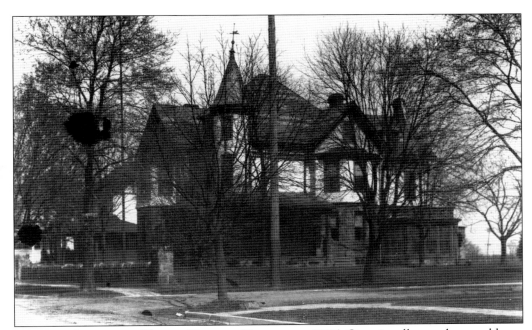

BENJAMIN LIPPINCOTT HOUSE, HADDON HEIGHTS, C. 1895. Occasionally travelers would pass by country estates such as the Lippincott house at the corner of the White Horse Pike and Green Street in Haddon Heights. Benjamin Lippincott spent $12,000 to build his house—an extraordinary sum for the day. (Courtesy Haddon Heights Library.)

THE BUTTONWOOD TREE, HADDON HEIGHTS, 1905. The buttonwood tree in front of the First Baptist Church was so famous in its day that a postcard was printed (view looking west to Camden). The tree surely predates the settlement of the town. The White Horse Pike was originally named Fifth Avenue in Haddon Heights due to where the road falls on the town's grid pattern. (Courtesy Haddon Heights Library.)

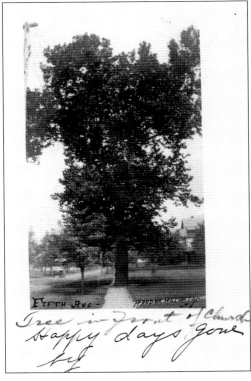

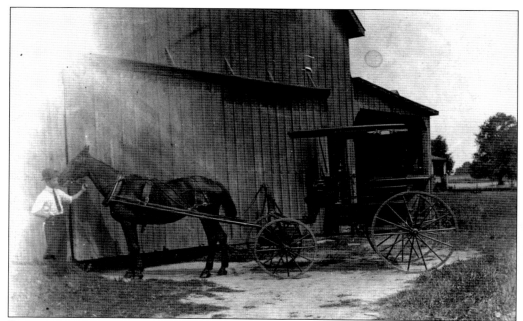

BENJAMIN CROOKES AND BILLIE, HADDON HEIGHTS, C. 1900. Benjamin Crookes's father owned this barn, which stood behind the First Baptist Church on the White Horse Pike (Fifth Avenue). Benjamin Crookes was a ship's chandler and probably drove Billie the horse to and from his workplace on the riverfront. (Courtesy Haddon Heights Library.)

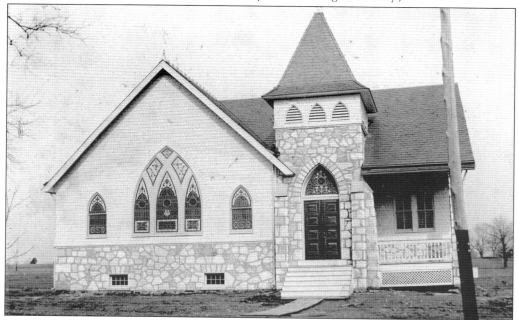

THE FIRST BAPTIST CHURCH, HADDON HEIGHTS, C. 1910. The First Baptist Church was the first church built in Haddon Heights. This photograph was taken just after its construction had been completed. Note the wooden plank laid out over the dirt on the approach to the entrance. A concrete path was poured later. (Courtesy Haddon Heights Library.)

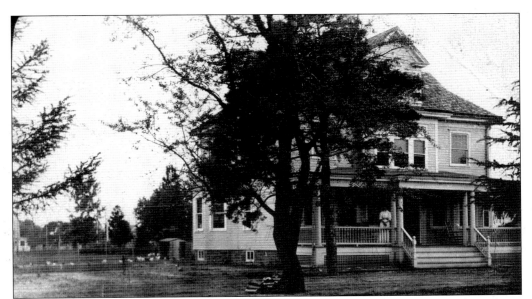

**RESIDENCE OF BENJAMIN CROOKES, HADDON HEIGHTS, C. 1910.** The Crookes residence and farm stands at 126 White Horse Pike, across from the First Baptist Church. Mrs. Crookes, known as "Mother" Crookes throughout town, poses on the porch. The house was a typical dwelling existing along the White Horse Pike at this time of suburban development. Daughter Josephine Crookes lived in the residence until she sold it in the 1970s. (Courtesy Haddon Heights Library.)

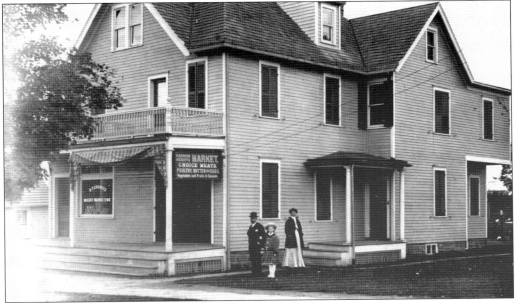

**HADDON HEIGHTS MARKET, C. 1910.** Benjamin Crookes, his wife, Mother Crookes, and daughter, Josephine, pose outside their new meat market at the corner of the White Horse Pike and Station Avenue. Mother Crookes convinced her husband to give up his position as ship's chandler and open the market. Crookes then no longer needed to commute to Camden. The Crookes residence can be seen at the far right. (Courtesy Haddon Heights Library.)

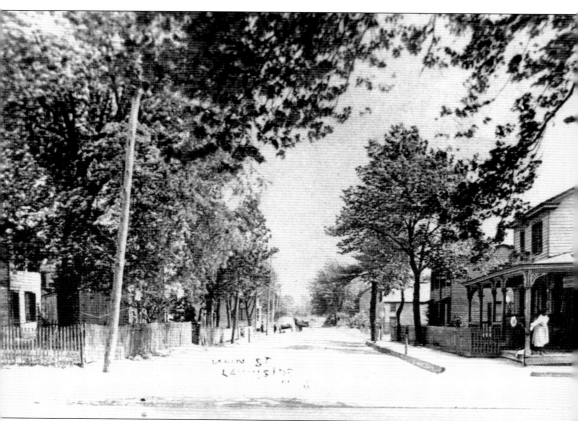

MAIN STREET, LAWNSIDE, C. 1890. Lawnside holds an important place in New Jersey history. Originally called Lawnton, the borough was settled in the 1790s and was a stop on the Underground Railroad, a route along which enslaved southern blacks were escorted to freedom in the North. Peter Mott, an African American preacher and also the first superintendent at Mount Pisgah African Methodist Episcopal Church, harbored these men and women in time of need. His residence is preserved as a museum. The borough is also the only historically African American–incorporated municipality in the northern United States. Lawnton was renamed Lawnside in 1907 by the Pennsylvania Railroad. (Courtesy the *Courier-Post*.)

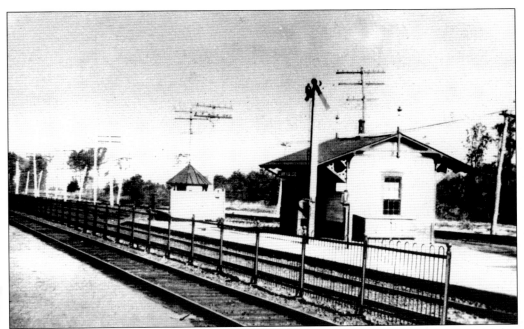

LAWNSIDE RAILROAD STATION, C. 1920. Lawnside was one of 15 stops along the Philadelphia and Atlantic Railroad. Residential development near the station did not appear to rise as quickly as in Collingswood, Haddon Heights, or Magnolia. (Courtesy the *Courier-Post*.)

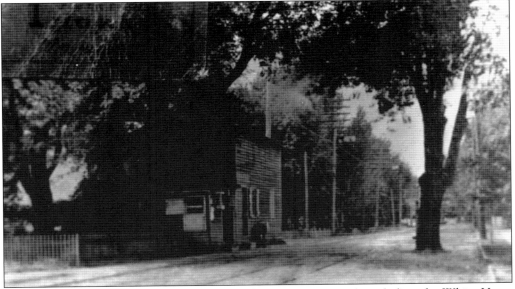

TOLL GATE, WESTMONT, C. 1890. In the early 1800s, many roads including the White Horse Pike were privatized and the owners charged tolls for travel upon them. Toll revenues covered the cost of operations, maintenance, and distribution to shareholders. By the 1870s, travelers had come to prefer the railroads to the turnpikes and revenues dropped off. Tolls could no longer cover the turnpike owners' costs, and maintenance of the roads was virtually eliminated. (Courtesy Collingswood Library.)

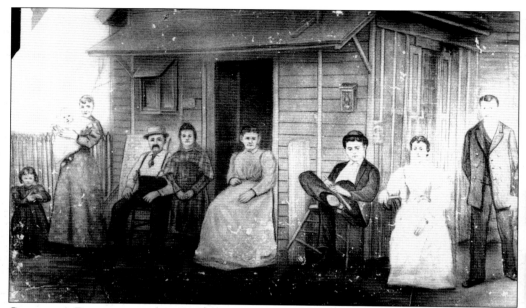

CHARCOAL DRAWING OF THE METZGER FAMILY, TOLL KEEPERS, MAGNOLIA, C. 1890. The Metzger family lived in the tollhouse at the White Horse Pike and La Pierre Avenue. As the value of the turnpikes declined, the call was made for the county to purchase the roads in order to maintain and improve them. The White Horse Pike became a toll-free road in 1893, and Camden County acquired the road in 1909. (Courtesy Magnolia Historical Society.)

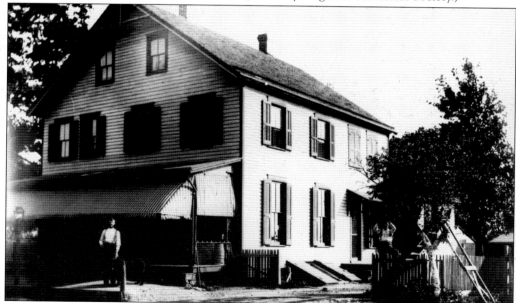

TOM BARRETT'S STORE, MAGNOLIA, C. 1900. Tom Barrett selected a valuable location for his business. His store, at 208 North White Horse Pike, was later purchased by T. Reinert, who added an auto repair shop and filling station to the right of the main building. Later, the main building became one of the New Jersey State Police substations. (Courtesy Magnolia Historical Society.)

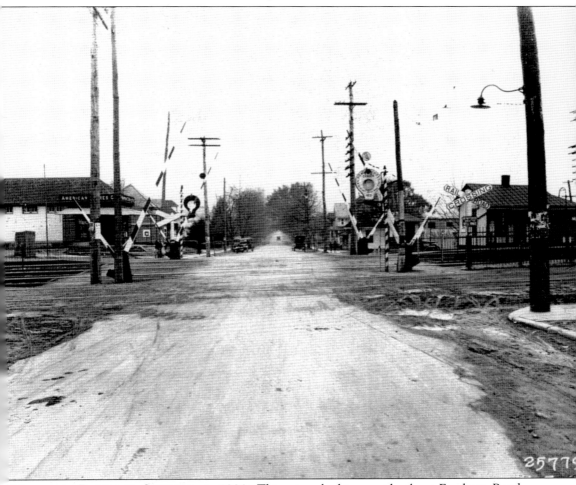

Magnolia Railroad Station, c. 1920. This view, looking south along Evesham Road at Atlantic Avenue in Magnolia, provides a sense of the volume of traffic of every mode in towns along the White Horse Pike. Here, the Philadelphia and Atlantic Railroad line (now the Atlantic City Railroad) and parallel trolley line run east to west (left to right) and are crossed by the busy, unpaved Evesham Road. Businesses and houses are located within easy walking distance of the train station, the small building behind the railroad crossing sign. Note the elaborate railroad crossing signals in place to warn of the danger of approaching trains. (Courtesy Magnolia Historical Society.)

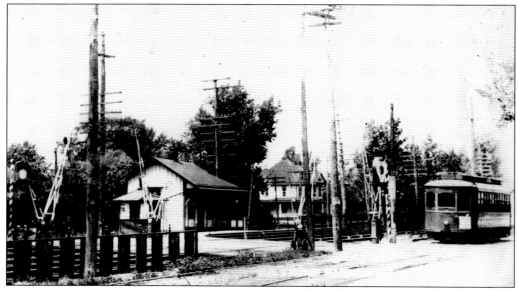

**A TROLLEY PULLS INTO MAGNOLIA, 1922.** The trolley from Camden arrives at the Magnolia station (Evesham Road and Atlantic Avenue) on its way east to Clementon. Trolleys ran parallel to the Philadelphia and Atlantic Railroad between 1905 and 1937. Their primary business was to transport commuters to and from downtown Camden. Commuters to other sections of Camden and to Philadelphia preferred to ride the railroad to and from work. (Courtesy Magnolia Historical Society.)

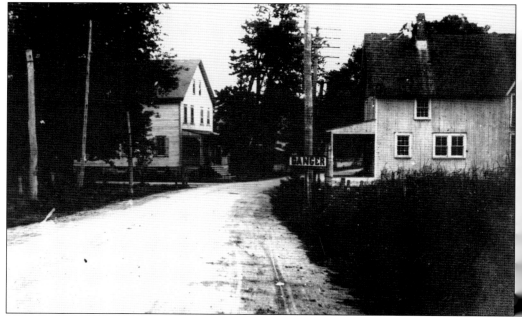

**DANGEROUS CURVE, STRATFORD, C. 1895.** Walt Whitman's train ride to the shore was smooth and quick, but travelers along the White Horse Pike were forced to maneuver their horse and buggy through deep ruts, mud, and tight curves such as this one at Laurel Road. The mill, the building on the left, was turned 90 degrees when the pike was widened. (Courtesy R. L. Long.)

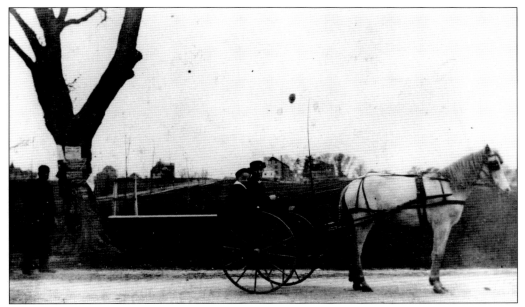

**MOTHER AND SON OUT FOR A DRIVE, STRATFORD, C. 1898.** This photograph of the White Horse Pike at Princeton Avenue shows not only the period's common mode of transportation, but also the housing development under way. In the background, to the right of the driver's whip, the Old Orchard Inn is visible. The large house on the right side is 201 Princeton Avenue. On the left side is 208 Princeton Avenue, and 209 is under construction. (Courtesy R. L. Long.)

**ICE-SKATING ALONG THE PIKE, STRATFORD, C. 1900.** Another hazard of the poorly maintained White Horse Pike is evident in this photograph. Low-lying areas tended to collect water, and in the winter, the pike would become an ice-skating rink. (Courtesy James F. Henry.)

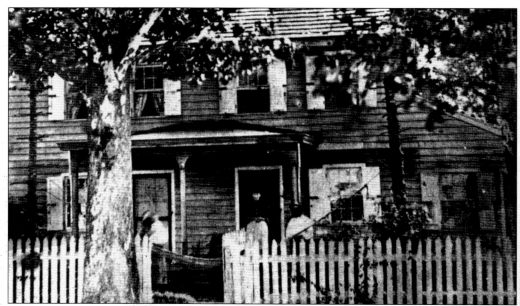

A RESIDENCE ON THE WHITE HORSE PIKE, STRATFORD, C. 1900. The tiny village of Stratford grew up around the White Horse Tavern. Nine houses were built in the vicinity of the tavern, the general store, Bert Sharp's blacksmith shop, and Levi Weigand's wheelwright shop. One of the homes, located at 15 South White Horse Pike, still stands and has been preserved as a historic site, the Quaker Store. (Courtesy James F. Henry.)

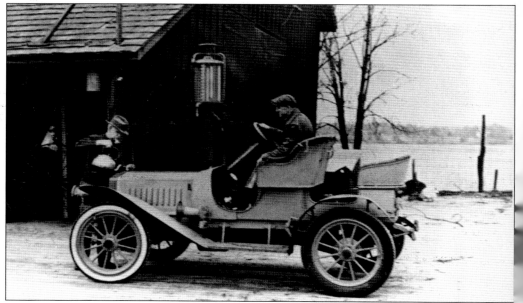

MR. REXON AND HIS FATHER, STRATFORD, C. 1905. Mr. Rexon was one of the first automobile owners in Stratford. Here, with the help of his father, he warms up his very early model that has the steering wheel on the right. Rexon's farm was an institution in the borough, famous for its large barn and, in winter, for its excellent sledding hill. The barn was destroyed by fire in the late 1960s. (Courtesy R. L. Long.)

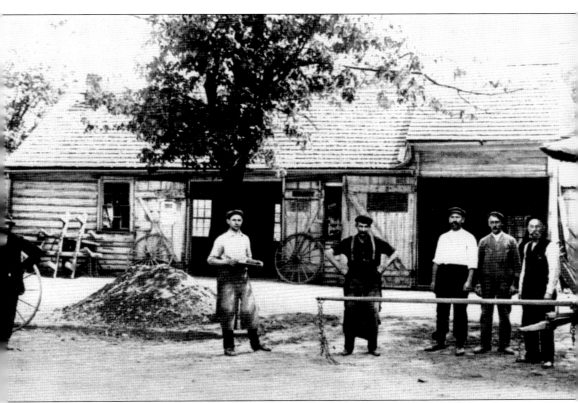

**BLACKSMITH AND WHEELWRIGHT ESTABLISHMENT, BERLIN, C. 1870.** Farmers and travelers relied on the local blacksmith and wheelwright for repairs to their conveyances and equipment. Blacksmiths worked in metals. They shod horses and crafted, maintained, and repaired farming tools, wagon hardware, and kitchen utensils. Wheelwrights made wheels but were also skilled carpenters who built and repaired wagons and carriages. (Courtesy Borough of Berlin.)

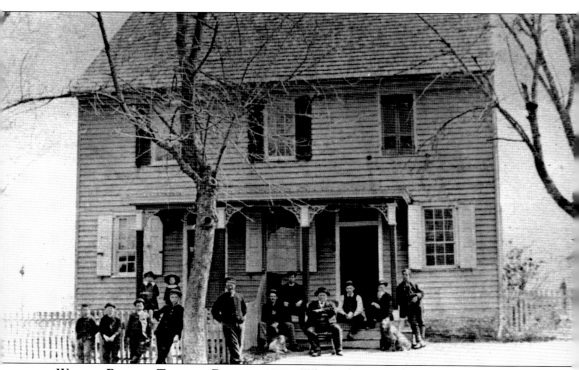

WRIGHT-BODINE TAVERN, BERLIN, 1870. Where there are hardworking blacksmiths and wheelwrights and where there are hardy travelers, there shall be a tavern. These men enjoy the beautiful day outside the tavern with their dogs, children, and perhaps a man of the cloth (fifth from the right). The Wright-Bodine Tavern is now a private residence. (Courtesy Borough of Berlin.)

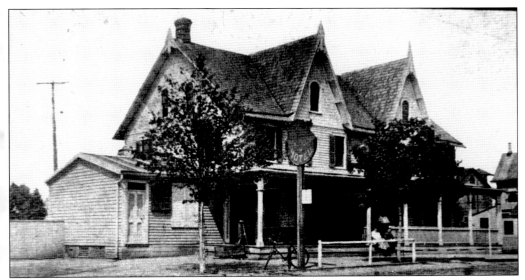

THE BERLIN HOTEL, C. 1880. Since 1826, the Berlin Hotel was a welcome sight for many travelers of the White Horse Pike. Arriving in Berlin meant that the journey to Camden or Absecon was half over. For the Leni-Lenape and early European settlers, Berlin signaled a supply of fresh water. For stagecoach passengers, the Berlin Hotel promised a comfortable place to rest jangled bones. Had Walt Whitman opted to travel the pike, he might have stayed here. (Courtesy Borough of Berlin.)

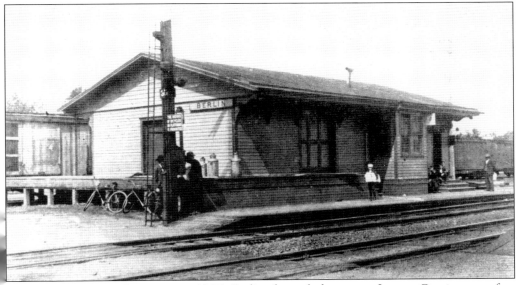

THE BERLIN TRAIN STATION, C. 1885. Berlin, formerly known as Long-a-Coming, was first settled in 1714 and lies at the midway point between Camden and Atlantic City. The Long-a-Coming train station was built in 1856 and renamed Magnolia in 1867. Due to confusion with the Borough of Magnolia situated not far to the west, the station and town were renamed again just three months later. The reasons for the name of Berlin are not documented, but history shows that a number of German immigrants had settled in the immediate area by that time. (Courtesy the *Courier-Post*.)

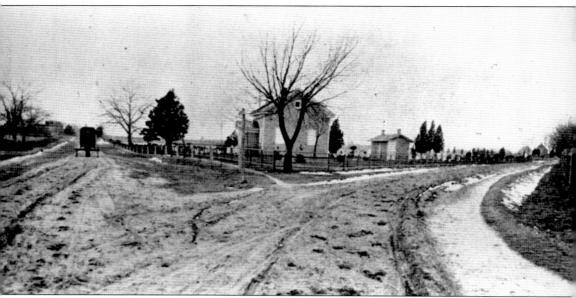

**BERLIN CEMETERY OFFICE, BERLIN, 1888.** The Berlin cemetery was established in 1766. As the White Horse Pike (right) was improved and widened and began to encroach upon the cemetery, old tombstones were used in creative ways, according to legend. Some became doorsteps, but even stranger is their use in outdoor ovens. Kathryn H. Chalmers, in her book *Down the Long-A-Coming*, explains this as the reason so many loaves of bread came out of the oven "inscribed, 'Sacred to the memory,' of some Jerseyman long ago gathered to his fathers." (Courtesy Borough of Berlin.)

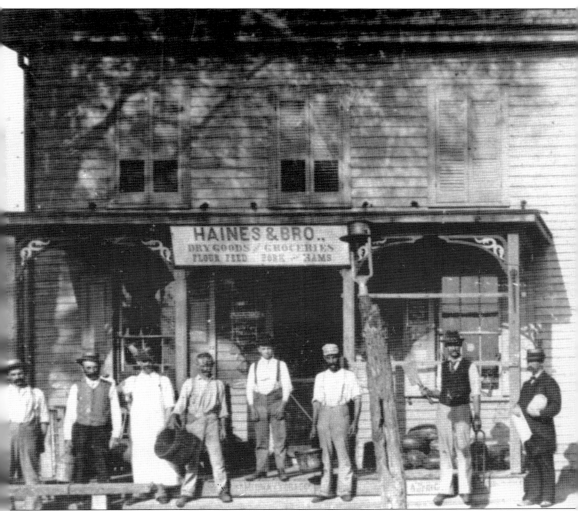

HAINES AND BROTHER DRY GOODS AND GROCERIES, BERLIN, C. 1900. As with other towns along the White Horse Pike, population growth brought business development. Shown are staff members of Haines and Brother, posing in front of the store where they sell dry goods, groceries, flour, feed, pork, and ham. The gentleman second from the right looks rather menacing, as he wields his cleaver. (Courtesy Borough of Berlin.)

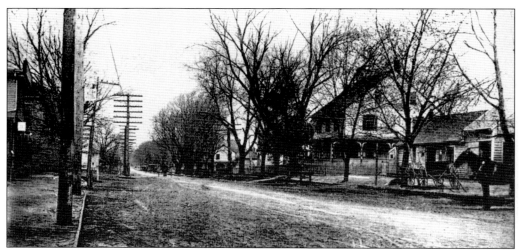

WHITE HORSE PIKE, BERLIN, C. 1900. This view looking north from Taunton Avenue shows that, for the length of its path through New Jersey, the White Horse Pike is a broad roadway lined with old trees and new businesses and residences. (Courtesy Borough of Berlin.)

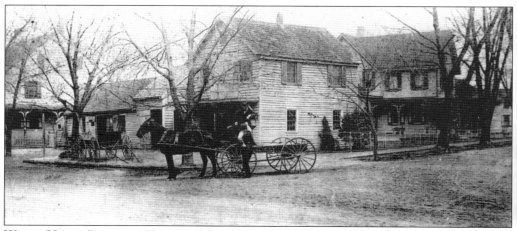

WHITE HORSE PIKE AND TAUNTON AVENUE, BERLIN, C. 1900. A draft horse waits patiently as two gentlemen meet at the large intersection of the White Horse Pike (running across the foreground) and Taunton Avenue. Although the roadways were broad and scenic, their rutted surfaces must have made any travel something less than comfortable. (Courtesy Borough of Berlin.)

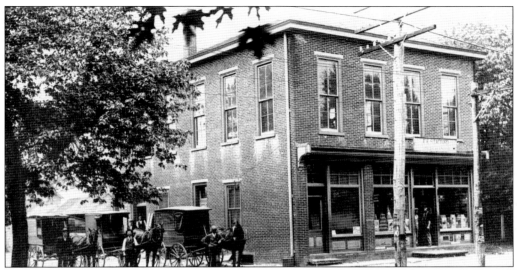

E. E. STAFFORD GENERAL MERCHANDISE, BERLIN, C. 1900. Members of Elmer Stafford's staff pose with their fleet of horse-drawn delivery wagons to the left of the new brick store. In 1910, E. E. Stafford's served as a temporary bank until construction on the Berlin National Bank building was completed. Elmer Stafford served Berlin well as postmaster, general store owner, bank president, and freeholder. (Courtesy Borough of Berlin.)

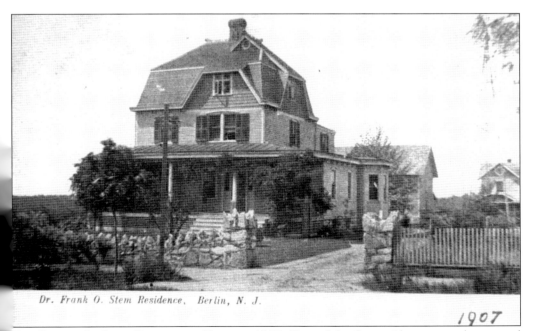

DR. FRANK O. STEM RESIDENCE, BERLIN, 1907. One of the fine residences travelers passed by was that of Dr. Frank O. Stem. The small building behind the house (right center) was a caretaker's cottage. (Courtesy Borough of Berlin.)

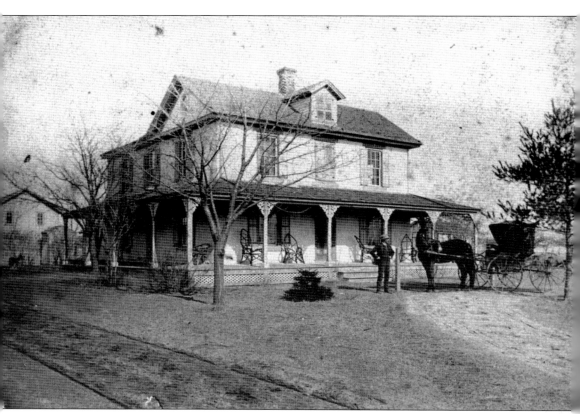

**H. M. Phillips Residence, Hammonton, c. 1880.** Upon crossing the border into Atlantic County, travelers passed the Phillips residence and farm on the White Horse Pike (Main Road). Here, Henry Phillips poses with his fine horse and handsome carriage. (Courtesy Ann and Bob Tomasello.)

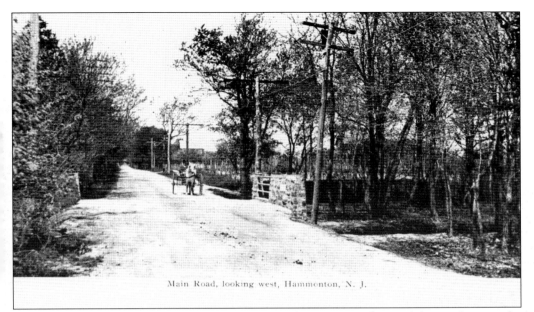

**MAIN ROAD, HAMMONTON, C. 1890.** As Walt Whitman passed into Atlantic County, the landscape became more forested. This view shows a traveler crossing a waterway along the White Horse Pike (Main Road). He is driving east toward what would later be known as Amatol, a munitions factory town built at the onset of World War I. (Courtesy Ann and Bob Tomasello.)

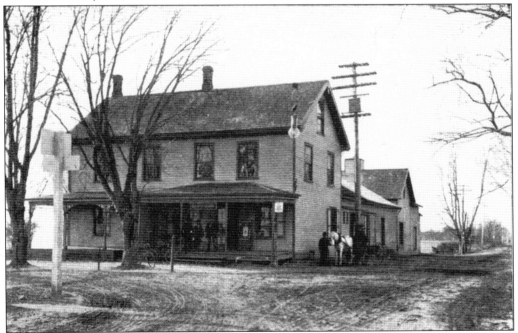

**ELVINS GENERAL STORE, HAMMONTON, C. 1890.** Elvins was just down the White Horse Pike from the Phillips farm, at the corner of Bellevue Avenue. Elvins was a Hammonton institution for many years. Townsfolk gathered there not only for their farming and general supplies but also to exchange information and enjoy one another's company. (Courtesy Ann and Bob Tomasello.)

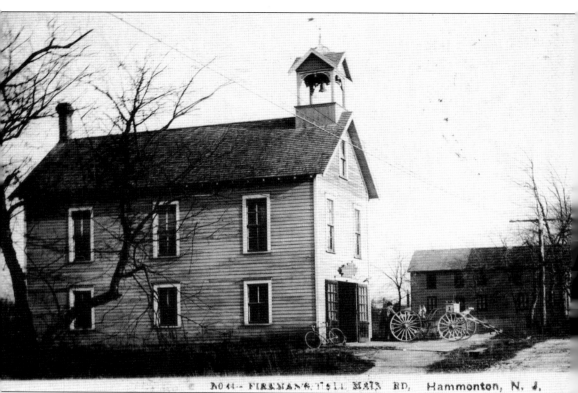

**Fireman's Hall No. 2, Hammonton, c. 1895.** Hammonton's No. 2 firehouse was located near the head of the White Horse Pike and Bellevue Avenue, not far from the center of town. Note the fire wagon outside the open doors, standing ready to be yoked to the horses that will pull it to the fire location. The bell in the tower called firefighters to duty. (Courtesy Ann and Bob Tomasello.)

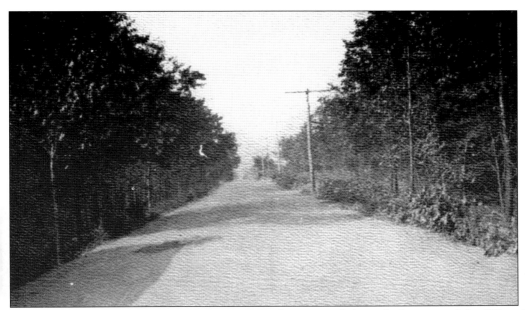

THE WHITE HORSE PIKE, ELWOOD, C. 1910. Looking toward Amatol, this view of the White Horse Pike shows dense forestation. This part of New Jersey provided natural resources such as charcoal and oak firewood, white cedar shingles, and, until the 1840s, bog iron wares for the markets in Philadelphia. (Courtesy Louise Palmisano.)

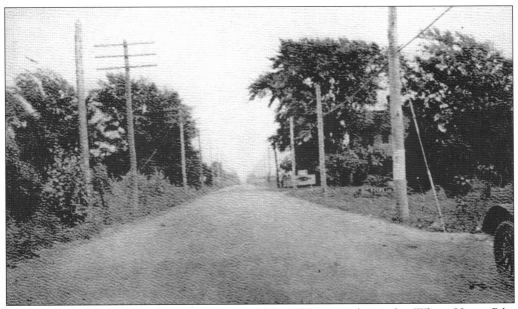

VIEW TOWARD HAMMONTON, ELWOOD, C. 1910. This view shows the White Horse Pike heading west toward Hammonton. In addition to the heavy goods native to the Pine Barrens, agricultural products such as beach plums, persimmons, and strawberries were carted up the pike to Camden and Philadelphia markets. Cabbages were the most valuable crop of south Jersey farms at this time, followed by the tomato. (Courtesy Louise Palmisano.)

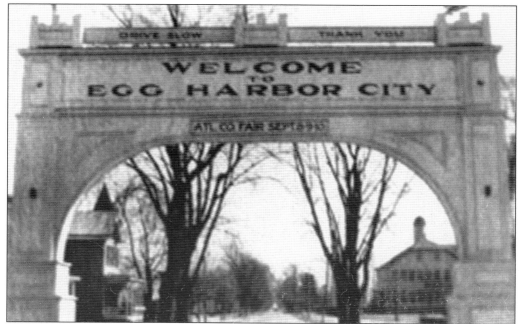

WELCOME TO EGG HARBOR CITY, C. 1905. Travelers received a warm welcome and gentle reminder to drive slowly when they arrived in Egg Harbor City. This plywood arch spanned the White Horse Pike (also known as Agassiz Street and County Road) at the center of Lincoln Park. The arch was removed when the pike was widened. The building with the cupola, visible to the right through the arch, is Public School No. 1. (Courtesy Egg Harbor City Historical Society.)

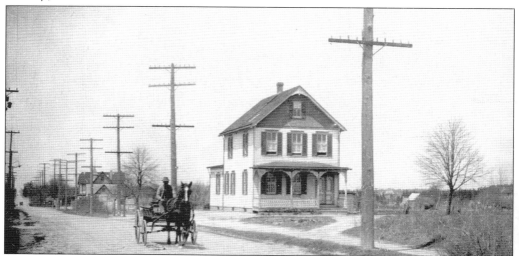

AGASSIZ STREET AT NEW YORK AVE, EGG HARBOR CITY, C. 1900. The White Horse Pike was known as Agassiz Street in Egg Harbor City at this time. The house in the center of the photograph was torn down to make a parking lot for Lou and Stell's Bar and Grill. The wagon driver is about to be overtaken by an automobile (far left), which is crossing the creek that supplied water for trains that passed through Egg Harbor City on their way to Atlantic City. (Courtesy Egg Harbor City Historical Society.)

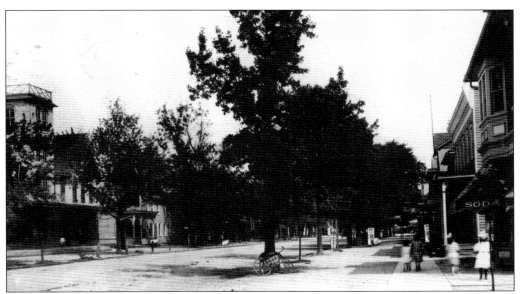

LOOKING NORTH ON AGASSIZ STREET, EGG HARBOR CITY, 1905. The White Horse Pike, often the main thoroughfare through a town, collected interesting businesses and groups of citizens. On the right is Dr. Boysen's pharmacy. The three-story tower atop the building on the left was once used as a platform for various bands performing evening concerts. The practice was discontinued when the bandstand was erected in Lincoln Park. (Courtesy Egg Harbor City Historical Society.)

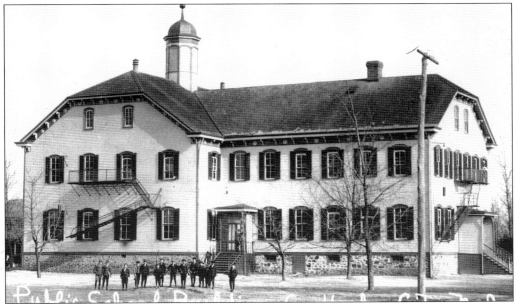

PUBLIC SCHOOL NO. 1, EGG HARBOR CITY, c. 1905. In this view from Buffalo Avenue, students on the back lawn were proud to show off the new addition to Public School No. 1. The original section, with the cupola, was built in 1876. The new section was built to accommodate the growing number of the city's students in kindergarten through high school. A third section was added later. (Courtesy Egg Harbor City Historical Society.)

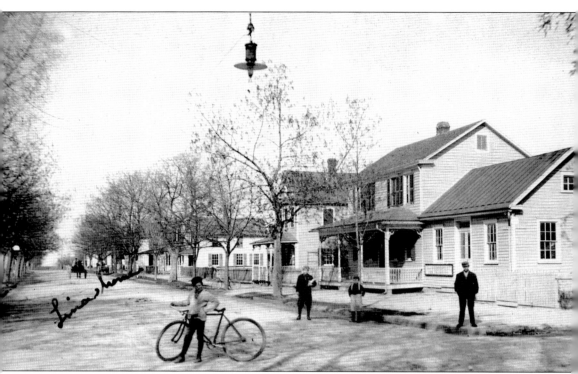

EARLY STREETLIGHTS ON THE PIKE, EGG HARBOR CITY, 1905. Note the streetlight suspended over the intersection of Cincinnati Avenue and the White Horse Pike (County Road). By 1905, many intersections throughout the city had been lighted. The *Egg Harbor Pilot*, one of several newspapers in the city, was produced in the building on the corner. (Courtesy Egg Harbor City Historical Society.)

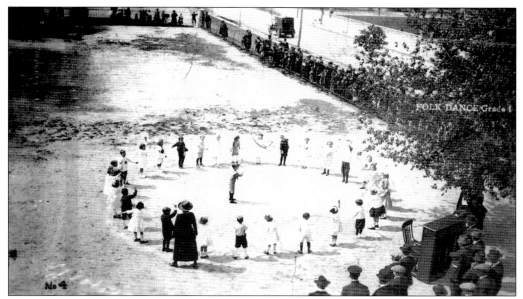

FOLK DANCE, EGG HARBOR CITY, C. 1905. First-graders at Public School No. 1, under the watchful eye of their teacher, perform a folk dance for parents and passersby. At the right, a truck is traveling the White Horse Pike (County Road). (Courtesy Egg Harbor City Historical Society.)

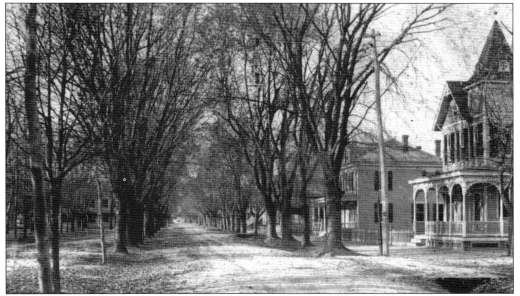

THE TREE-LINED PIKE, EGG HARBOR CITY, C. 1900. This view of the White Horse Pike from Buffalo Avenue before the welcome arch was built depicts the stateliness of life along the pike. Old-growth trees shaded the exquisite homes seen in all developing towns along its route. Travelers may have forgotten the bumpy ride, albeit temporarily, while enjoying such scenery. Although many of the houses and trees have long since been razed, the house on the right remains—minus its cupola, trees, and inviting porch. (Courtesy Egg Harbor City Historical Society.)

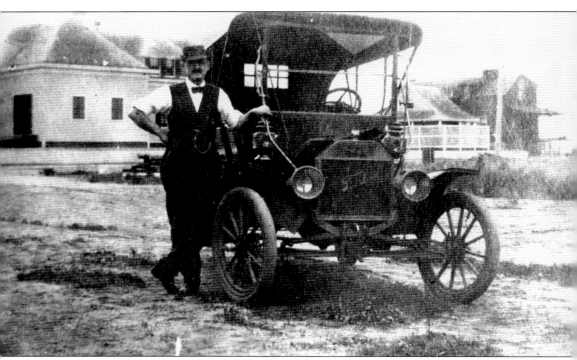

**RIDING THE WAVE OF CHANGE, COLLINGSWOOD, 1910.** Charles Quint owned the first automobile in Collingswood. Many would soon follow in his tire tracks. The lure of the automobile was irresistible. Advertisements romanticized the glamour of car ownership, buyers could pay in installments, and roads were being paved with concrete by the time Quint purchased his Ford. The automobile would soon change the face of travel from city to shore. (Courtesy Collingswood Library.)

# Three

# THE AUTOMOBILE AND THE BRIDGE

The second and third phenomena contributing to the success of the White Horse Pike go hand in hand. If not for the burgeoning popularity of the automobile, the need for a massive bridge across the Delaware River might not have been so urgent. Competition in Detroit made automobiles cheap. The freedom they afforded made them beloved. By 1924, one in seven Americans owned a car.

With population growth came the need to move goods. Uninterrupted transport of produce and goods was required. Tempers often flared at the delays caused by backups on the ferries across the Delaware River.

The Delaware River Bridge Joint Commission was formed in 1919 and moved swiftly toward implementing Ralph Modjeski's plan for a suspension bridge across the river. The bridge defined Ralph Modjeski's career. His innovations in design and construction and his vision for traffic requirements were critical to the success of the massive four-year project, which began on January 6, 1922.

The images in this chapter depict the bustling ferry ports and the Delaware River Bridge construction.

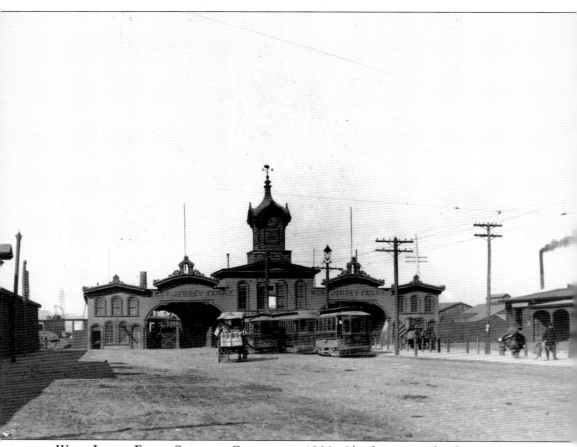

**WEST JERSEY FERRY STATION, CAMDEN, C. 1900.** Also known as the Cooper Street Ferry, this station served commuters and visitors alike. Passengers ferried across the Delaware River from Philadelphia would switch here to their next mode of transportation: the train or the trolley. Train service extended parallel to the White Horse Pike to Atlantic City and other shore points. The trolleys ran parallel to the White Horse Pike to developing towns as far south as Clementon. Soon, ferry services were overwhelmed. Commuters from Philadelphia to Camden grew frustrated with delays at the riverfront. Weekend excursionists jammed the ferry ports. Government officials in Camden and Philadelphia debated the need for a bridge across the river as early as 1818, but it was not until 1919 that serious studies were undertaken by the Delaware River Bridge Joint Commission. (Courtesy Collingswood Library.)

**RALPH MODJESKI, C. 1925.** In one of its first acts, the Delaware River Bridge Joint Commission named Ralph Modjeski the bridge engineer. Modjeski's reputation for creative bridge design and construction techniques had grown since the beginning of the 20th century. The Delaware River Bridge (renamed the Benjamin Franklin Bridge in 1956) proved to be his career-defining project. (Courtesy Modjeski and Masters.)

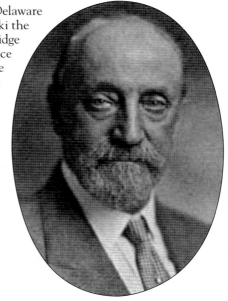

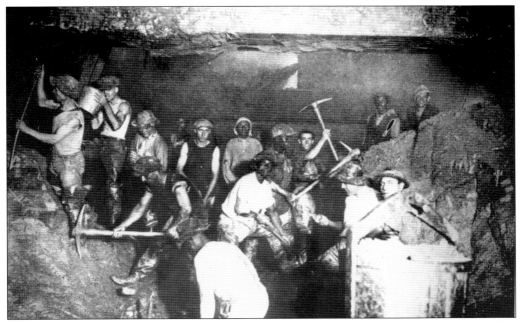

**DIGGING THE FOUNDATION DEEP BENEATH THE RIVER, 1922.** Pres. Warren G. Harding signed legislation authorizing construction of the Delaware River Bridge, and construction began on January 6, 1922. Supporting structures were based deep beneath the river: 65 feet deep on the Philadelphia side, and 105 feet deep on the Camden side. (Courtesy Delaware River Port Authority.)

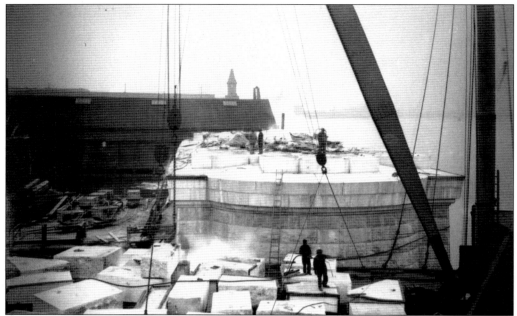

**PIER CONSTRUCTION BEGINS, 1922.** The piers and anchorages for the Delaware River Bridge were finished with huge granite stones cut to fit. In this view, laborers work on the jigsaw puzzle that will become Pier A. The completed piers are the foundations for the steel towers, which will rise to a height of 385 feet. (Courtesy Delaware River Port Authority.)

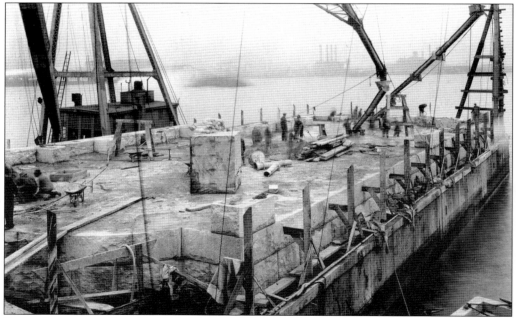

**STONE LAYING ON PIER B, 1922.** This view of work on Pier B provides a sense of the enormity of the task. Masonry workers are dwarfed by the granite stones and the machinery used to lift them into place. (Courtesy Delaware River Port Authority.)

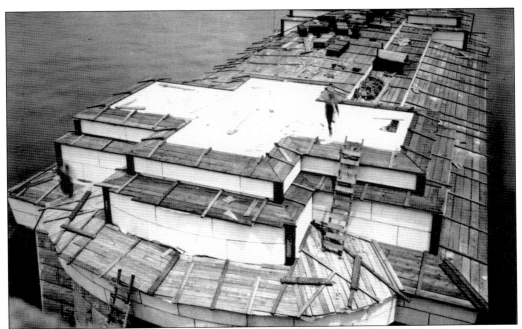

PIER B COMPLETED AND PROTECTED, 1923. The granite has been laid, and Pier B is readied for the next phase of construction. Note that the exquisite stonework is protected from the steelwork that is to follow by a casing of wooden planks. (Courtesy Delaware River Port Authority.)

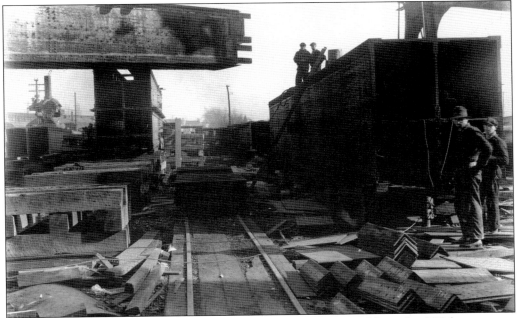

STEELTON SHOP, MAIN TOWERS, 1923. Work begins on assembling the 385-foot support towers. In order to deliver the huge steel beams, a railroad was constructed leading directly to the construction site. Both support towers were constructed simultaneously. (Courtesy Delaware River Port Authority.)

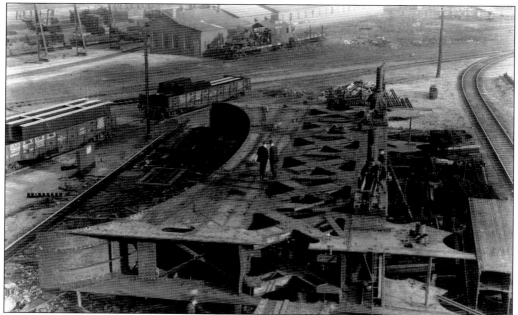

TOWER B PORTAL STRUT, 1923. Engineers inspect a section of one of two struts as it is constructed. The Delaware River Bridge was to be the longest suspension bridge of its time—1,750 feet. The massive tower portions, through which the bridge's support cables were strung, were later placed upon their below-river foundation. (Courtesy Delaware River Port Authority.)

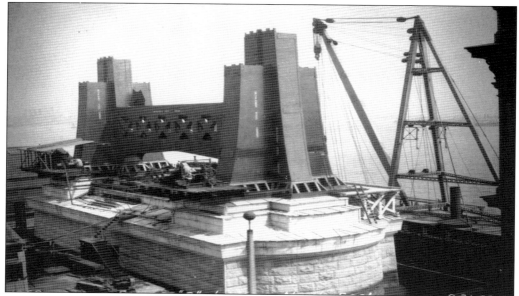

THE FIRST PORTAL STRUT PORTION IS PLACED, 1923. The first portion of the massive steel support tower is placed upon its foundation. The temporary wooden staircase at the bottom of the photograph provides a reference by which to gauge the size of the structure. The bridge was designed to carry both automobile and train traffic between Camden and Philadelphia. (Courtesy Delaware River Port Authority.)

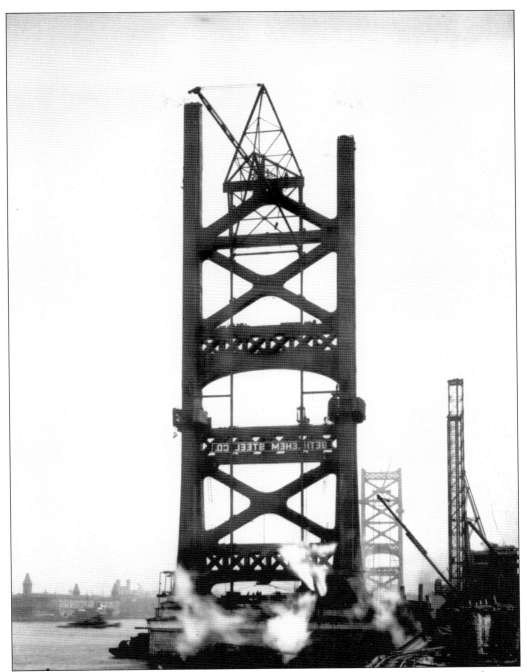

**THE SECOND TOWER NEARS COMPLETION, 1924.** The support tower in the foreground awaits the last few sections of steel struts. The massive crane system attached to the structure raised and leveraged the tower sections. These graceful 385-foot towers were constructed of silicon steel, another Modjeski innovation. (Courtesy Delaware River Port Authority.)

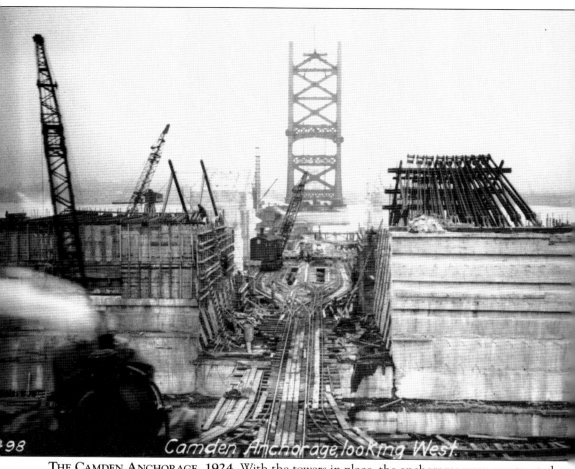

THE CAMDEN ANCHORAGE, 1924. With the towers in place, the anchorages were constructed. This view from Camden shows the massive structure taking shape. The anchorages support the roadway as it ascends from each city. Each covers three-fourths of an acre and rises 175 feet above ground level. Combined, the anchorages were built with 216,000 tons of stone. (Courtesy Delaware River Port Authority.)

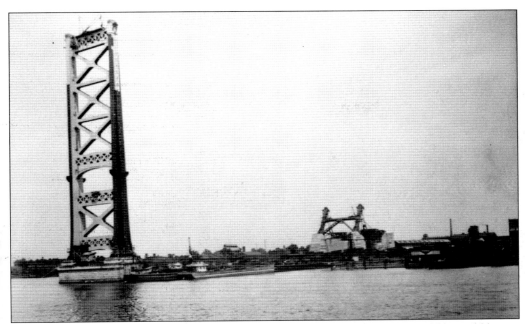

**PREPARING THE FOOTBRIDGE, 1924.** Before construction of the suspension cables could begin, ropes were strung as the first step in building footbridges for the workmen. High above the Delaware River, laborers, engineers, and inspectors traversed these temporary wooden structures at various stages of construction. (Courtesy Delaware River Port Authority.)

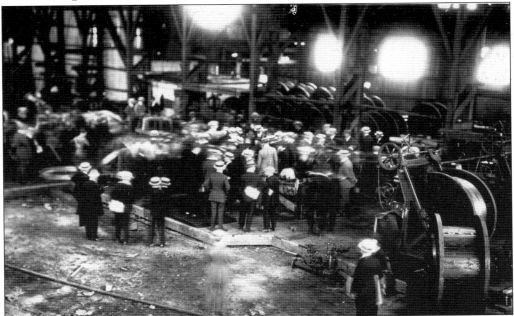

**INSPECTING THE CABLE REELING PLANT, CAMDEN, 1924.** Construction of the Delaware River Bridge was truly an engineering marvel. This large inspection party of engineers, dignitaries, and newsmen oversees preparations for winding and installing the bridge support cables. (Courtesy Delaware River Port Authority.)

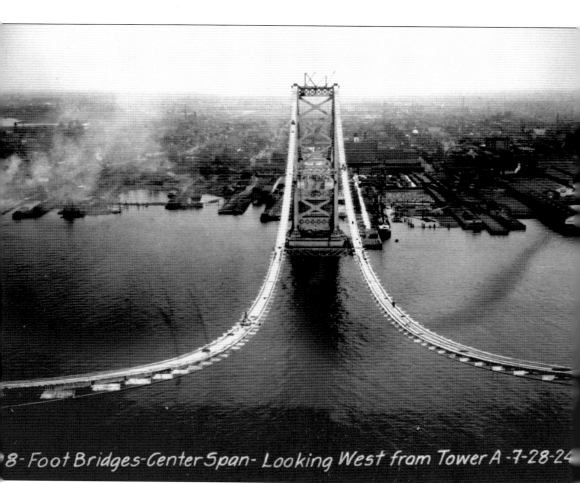

**FOOTBRIDGES SPAN THE RIVER, 1924.** This image, looking west to Philadelphia, provides a unique (and stomach-churning) view from atop the Camden side support tower. The footbridges are in place, allowing laborers to begin work on the support cables. (Courtesy Delaware River Port Authority.)

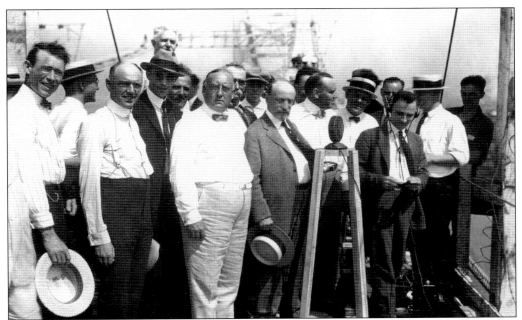

**INSPECTION PARTY ON THE FOOTBRIDGE, 1924.** Ralph Modjeski (center, in jacket) leads an inspection party on an official crossing of the footbridge. Modjeski's energy was unflagging. Despite his advancing years, he remained very active on the construction site. (Courtesy Delaware River Port Authority.)

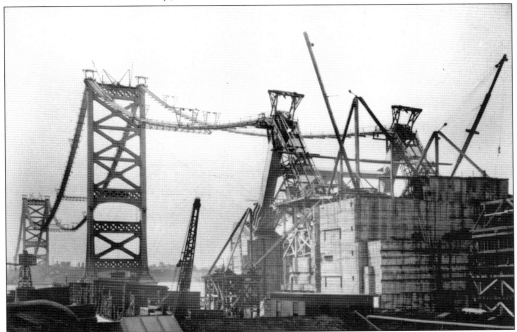

**THE BRIDGE TAKES SHAPE, 1924.** With the steel support towers in place and the footbridge strung high above the river, the stage is set for the placement of the steel deck and the support cables. (Courtesy Delaware River Port Authority.)

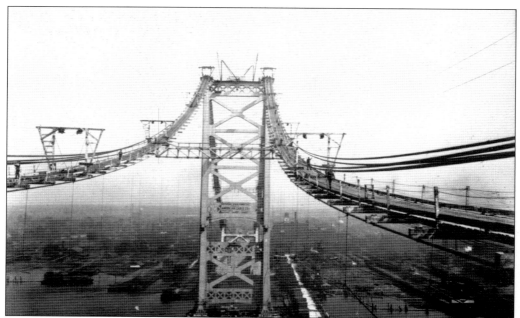

THE NEW BIRD'S-EYE VIEW OF CAMDEN, 1924. Workmen walk east toward Camden and see the city from a new vantage point atop the Delaware River Bridge. The footbridge was fitted with machinery in preparation for cabling the bridge. The cables were composed of 3,500 tons of a special steel alloy wire. (Courtesy Delaware River Port Authority.)

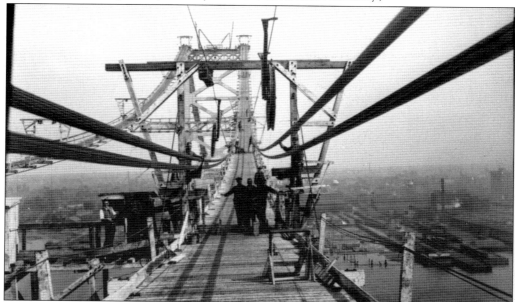

THE VIEW TO CAMDEN FROM ATOP THE BRIDGE, 1924. A second image from the footbridge, where cabling was soon to begin, depicts the size and heft of the footbridges. Their construction required enormous amounts of lumber. They needed to not only support the tons of steel cable but also to withstand the elements, including high winds. (Courtesy Delaware River Port Authority.)

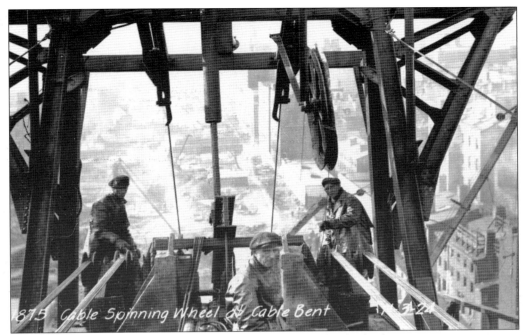

CABLE SPINNING AT THE TOP OF THE BRIDGE, 1924. The footbridges were soon put to use by the cable spinners. The huge supporting cables were spun of 25,000 miles of steel alloy wire. (Courtesy Delaware River Port Authority.)

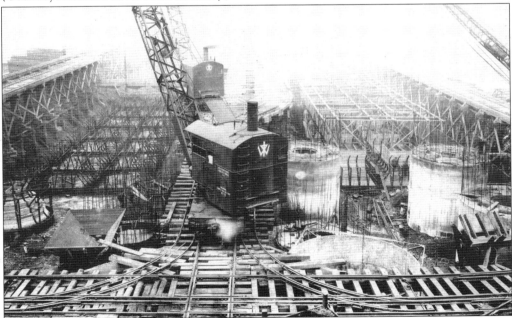

THE CAMDEN ANCHORAGE NEARS COMPLETION, 1925. The infrastructure required to build the massive anchorages is visible in this photograph of that on the Camden side. The approach split Camden in half and razed one of its most historic and affluent neighborhoods. (Courtesy Delaware River Port Authority.)

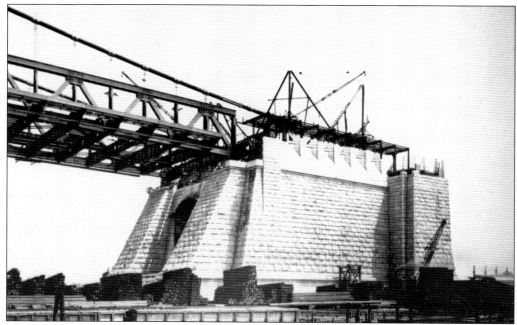

PART OF THE BRIDGE DECK IS PLACED ONTO ITS ANCHORAGE, 1925. Anchorages, covered in the same granite stones as the piers, serve as the foundation for each end of the bridge's steel deck, or roadway. The length of the main span across the river is 1,750 feet, and with the approaches from Philadelphia and Camden, its total length is an extraordinary 1.82 miles. A total of 61,700 tons of steel was used in the construction of the bridge. (Courtesy Delaware River Port Authority.)

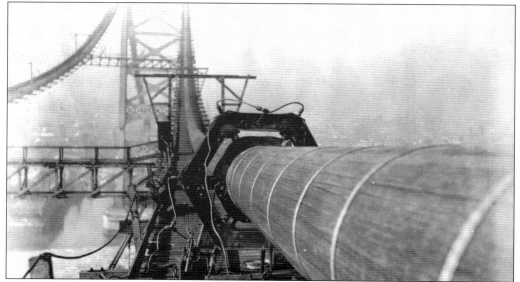

NORTH CABLE SQUEEZING FRAME, 1925. This view from the top of the Camden side tower west to Philadelphia captures the machinery that squeezes the 19,000 individual wires into one 30-inch-wide supporting cable. Combined with the trussed deck, these cables were designed to support 60,000 tons. (Courtesy Delaware River Port Authority.)

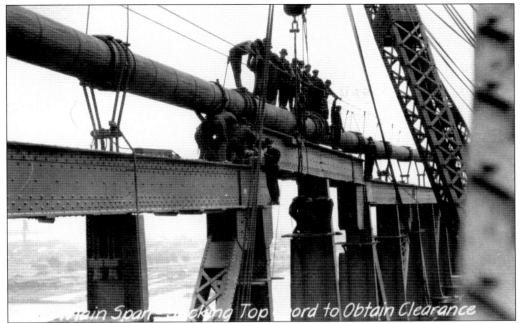

**PRECISION IS REQUIRED, 1925.** As with any construction project, regardless of its size, strict tolerances must be met. Laborers struggle to place a portion of the structure according to specifications. (Courtesy Delaware River Port Authority.)

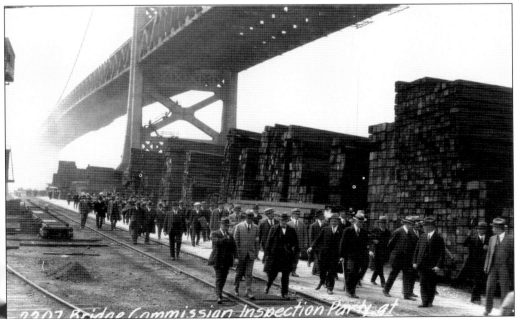

**INSPECTION IN CAMDEN, 1925.** The skeleton of the Delaware River Bridge looms over the inspection party as it again assembles at the Baird Pier in Camden. The excitement and wonder is apparent on the men's faces. The opening of the bridge is just over a year away. (Courtesy Delaware River Port Authority.)

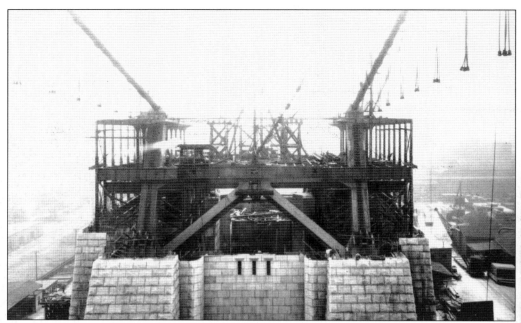

**CAMDEN ANCHORAGE FROM BRIDGE DECK, 1925.** Looking east from the bridge's deck, this unique view shows the Camden anchorage. Suspension cables are in place overhead. The approach roadway will rest atop the anchorage and be hung from the dangling cables in order to interlock with the existing bridge deck. (Courtesy Delaware River Port Authority.)

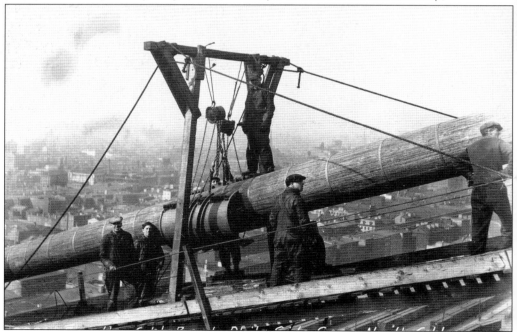

**ERECTING CABLE BAND, PHILADELPHIA, 1925.** While work continued on the Philadelphia approach, laborers erected the cable band high above. This view, looking northwest, shows men working on the bridge's north cable. (Courtesy Delaware River Port Authority.)

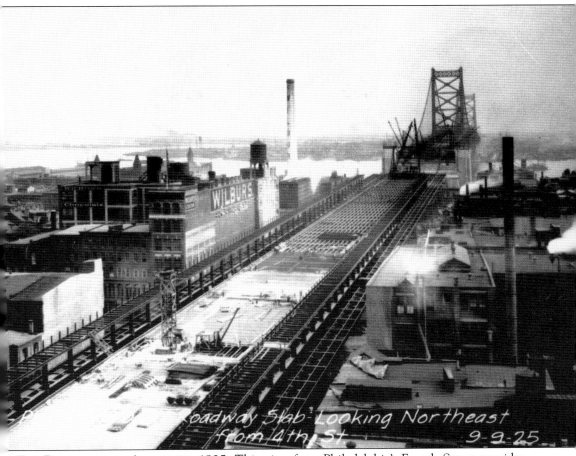

THE PHILADELPHIA APPROACH, 1925. This view from Philadelphia's Fourth Street provides a good sense of the incredible scope of the bridge project. The roadway is taking shape, as are the rapid transit tracks on either side of the bridge approach. The amount of real estate gobbled up by the approach did not have a significant effect on Philadelphia. In Camden, the story was different. Some blame the decline of Camden on the divisive nature of the bridge construction. (Courtesy Delaware River Port Authority.)

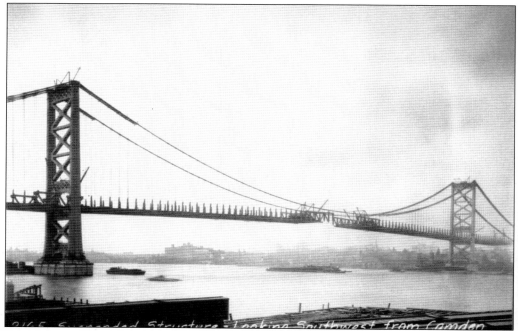

EAST MEETS WEST OVER THE DELAWARE RIVER, 1925. The skeletal structure of the bridge is almost completed. The deck at mid-span will rise 135 feet above the river, allowing even the tallest of ships passage. (Courtesy Delaware River Port Authority.)

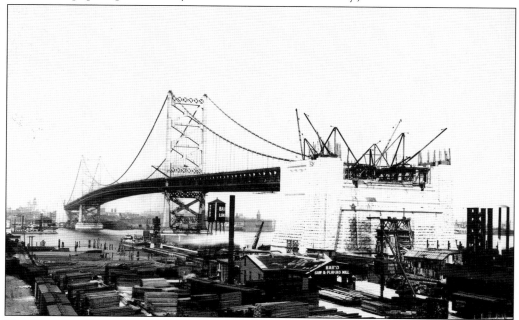

THE RIVER IS BRIDGED, 1925. With the structure across the Delaware nearly complete, work continues on the approach from Camden. The deadline for completion is nine months away. Note that the bridge construction project required its own lumberyard, sawmill, and railroad system. (Courtesy Delaware River Port Authority.)

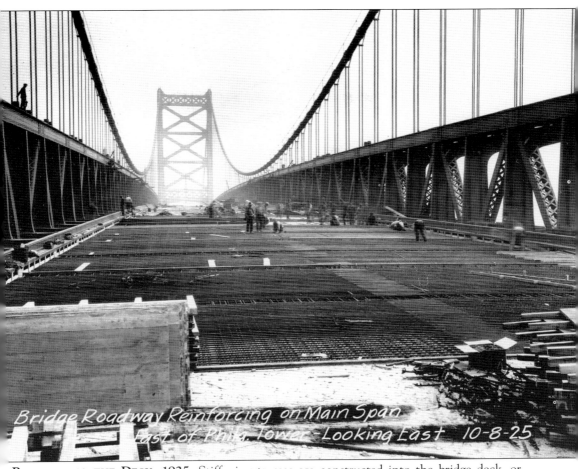

REINFORCING THE DECK, 1925. Stiffening trusses are constructed into the bridge deck, or roadway, to help support the load of both the bridge itself and the traffic that will soon cross it. The process was common in constructing suspension bridges to manage the opposing forces inherent in their design. (Courtesy Delaware River Port Authority.)

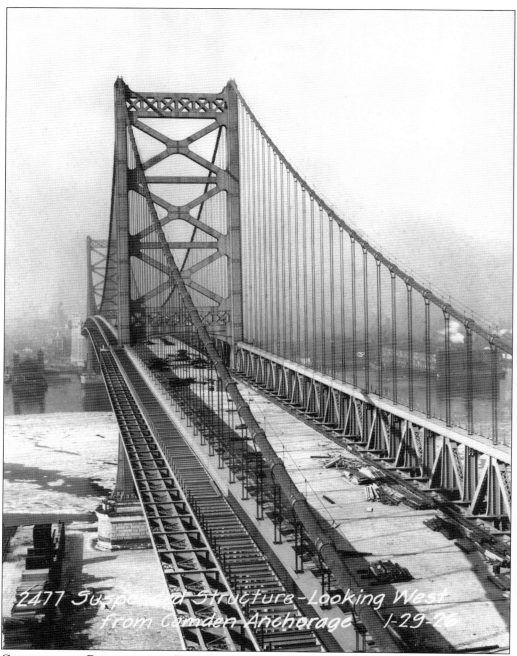

**CAMDEN AND PHILADELPHIA FOREVER LINKED, 1926.** This view, looking west from the Camden anchorage, shows the skeletal bridge is completed, providing a permanent link between Camden and Philadelphia. The footbridges have been removed, and the deck awaits its asphalt finish. (Courtesy Delaware River Port Authority.)

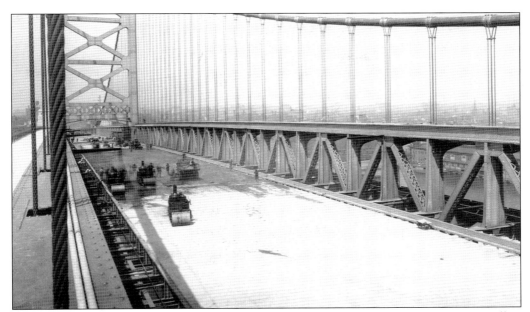

PAVING THE BRIDGE ROADWAY, 1926. Laborers spread hot asphalt for the fleet of steamrollers to compress. Ralph Modjeski's design was visionary in anticipating the extraordinary flow of traffic over the bridge. The bridge accommodated six lanes of traffic plus two streetcar tracks. In addition, two rapid transit tracks were constructed on the outside of the bridge on either side of the roadway. (Courtesy Delaware River Port Authority.)

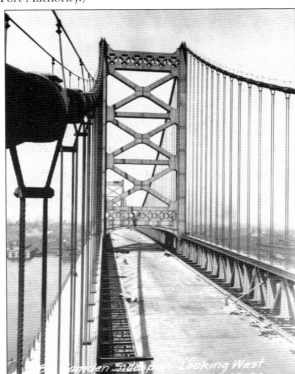

FINISHING TOUCHES ON THE ROADWAY, 1926. With the official bridge dedication and opening just six weeks away, the roadway is paved. In this view, looking west toward Philadelphia, laborers are working on the junction of the roadway and the streetcar tracks on the Camden side of the span. (Courtesy Delaware River Port Authority.)

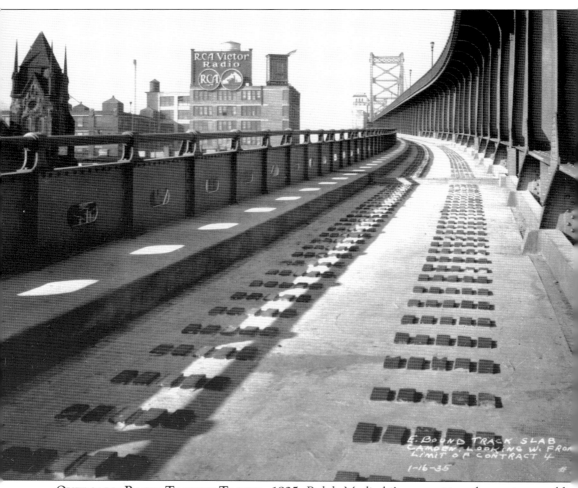

OUTBOARD RAPID TRANSIT TRACKS, 1935. Ralph Modjeski's recognition that trains would remain a viable mode of transportation between Philadelphia and Camden is evident in this view from the north track slab east to Camden. Although they were not used right away, these rapid transit lanes, on the exterior of the bridge, have been in use since 1936. Today, more than 38,000 commuters and day-trippers ride the PATCO Hi-Speed Line over the bridge. (Courtesy Delaware River Port Authority.)

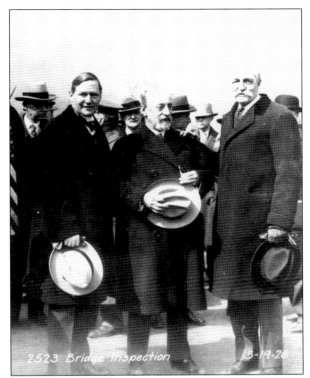

THE FIRST OF MANY CEREMONIES CELEBRATING THE BRIDGE, 1926. Posing atop the bridge during an official inspection are, from left to right, New Jersey Gov. A. Harry Moore, bridge engineer Ralph Modjeski, and Pennsylvania Gov. Gifford Pinchot. The Delaware River Bridge officially opened on July 1, 1926, in time for Philadelphia's sesquicentennial celebration. An estimated 100,000 citizens crossed the bridge on foot that day. Pres. Herbert Hoover participated in a dedication ceremony on July 2, 1926, when the bridge opened to vehicular traffic. (Courtesy Delaware River Port Authority.)

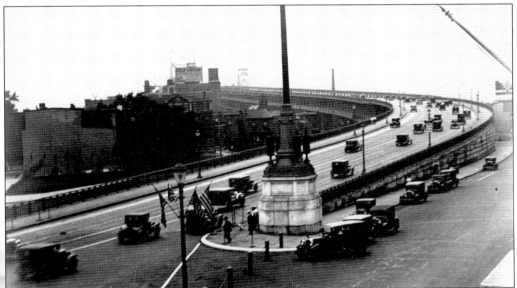

TRAFFIC ON THE DELAWARE RIVER BRIDGE, CAMDEN, 1926. In this image, a steady flow of cars proceeds from Camden toward Philadelphia. The volume of traffic over the bridge exceeded everyone's expectations: 35,000 vehicles a day crossed the bridge. In the three months following its opening, 2 million vehicles crossed—double the volume predicted. Bridge officials were so impressed by the success of the bridge that they briefly considered converting the rapid transit rail lines into additional vehicular lanes. (Courtesy Delaware River Port Authority.)

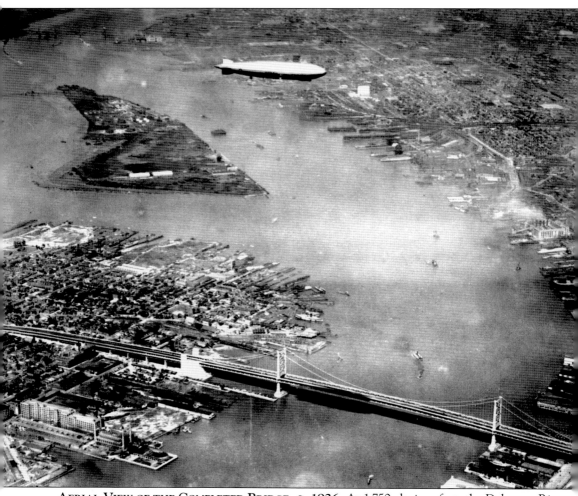

**AERIAL VIEW OF THE COMPLETED BRIDGE, C. 1926.** At 1,750 glorious feet, the Delaware River Bridge was, for a time, the longest suspension bridge in the world. Ralph Modjeski's reputation is cemented as one of the great bridge builders of all time. He designed two other bridges in the immediate area: the Tacony-Palmyra Bridge, which also spans the Delaware River, and the stunning Henry Avenue Bridge over the Wissahickon Creek. (Courtesy Delaware River Port Authority.)

*Four*

# DEVELOPMENT ALONG THE PIKE

With the Delaware River bridged and automobiles garaged, the scene was set for booming suburbanization a mere generation after Walt Whitman rode the rails through the undeveloped farmland of southern New Jersey.

Residential and business development was rampant along the White Horse Pike. The road's tight curves were eased, lanes were widened, and concrete paving was poured. Overhead lamps lit busy intersections. A variety of signals controlled ever-increasing traffic flow. Sodium vapor lighting illuminated the dark path from city to shore.

With improvement came the loss of some of the endearing qualities of the White Horse Pike. Trees were felled to make room for cars, trucks, and buses. Farms were sold off to developers. When the U.S. government instituted its program of numbering federal highways, the White Horse Pike lost its series of provincial names. In 1925, monikers such as Agassiz Avenue, County Road, Main Road, and Fifth Avenue were lost to the defining label of U.S. Route 30.

Despite the government's best efforts, Route 30 remains best known as the White Horse Pike.

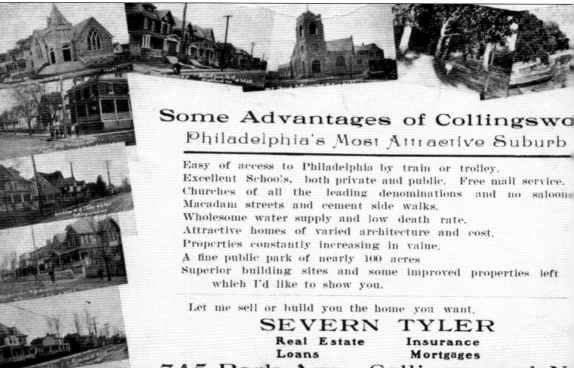

THE REAL ESTATE MARKET BOOMS, 1909. How could crowded and dirty city dwellers resist Severn Tyler's postcard advertisement? In the few short years since Walt Whitman's ride through farmland with little development, towns like Collingswood and West Collingswood were developing fast. Just a short commute from Philadelphia and Camden, towns along the White Horse Pike offered the American Dream. Tyler was a master marketer. His message on the back of the postcard reads: "Dear Sir: Now is the time for you to select your home. Let me help you do it. I can please you in price and terms. At Market Street Ferry take Haddonfield car to Lees avenue, Collingswood. You will find me at the corner of Park and Lees avenues. Phone or send postal when coming. Yours very truly, Severn Tyler." The sender included this note: "P.S. We'll make room for the cows and milk 'em, too!" (Courtesy Collingswood Library.)

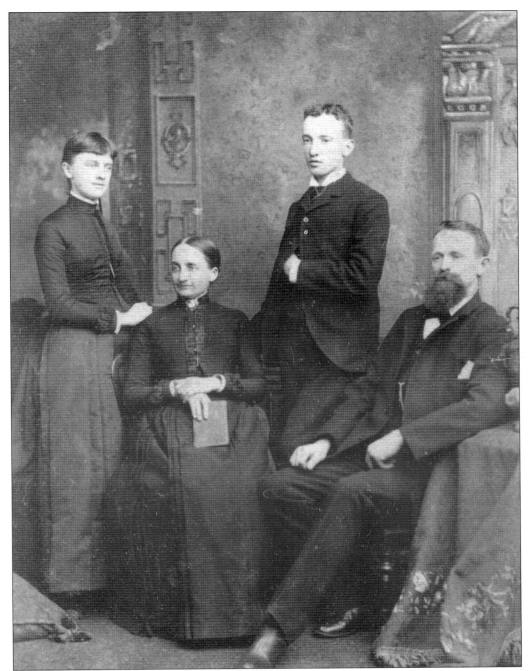

**THE RICHARD T. COLLINGS FAMILY, C. 1900.** Richard Collings (right) was an influential member of the influential family after which Collingswood is named. He served as mayor of the town for six years. He also served as vice chairman of the Delaware River Bridge Joint Commission and, through his efforts, became known as "the father of the Delaware River Bridge." Pictured with him, from left to right, are his daughter, his wife, and his son Isaac Zane Collings. (Courtesy Collingswood Library.)

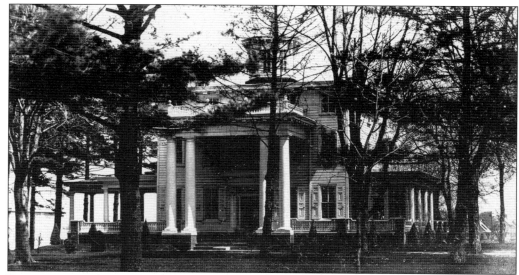

DUNGARVIN—THE WILLIAM HURLEY RESIDENCE, WEST COLLINGSWOOD, C. 1914. Those who responded to Severn Tyler's advertisement would have been pleased to see Dungarvin. William Hurley, owner of Camden's largest department store, built his impressive residence at 315 White Horse Pike. Hurley's was a Camden institution from 1890 until it closed in 1956. William Hurley served as president of the Camden Board of Trade and was an advocate for good urban planning, including a system of city streets and county roads. He was also Camden's first automobile owner. (Courtesy Collingswood Library.)

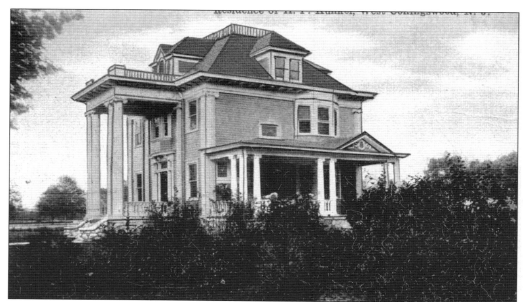

THE KUNKEL RESIDENCE, WEST COLLINGSWOOD, C. 1914. Postcard printers in the early 20th century had a passion for inviting scenes, such as that of the H. F. Kunkel residence at the corner of the White Horse Pike and Collings Avenue. (Courtesy Collingswood Library.)

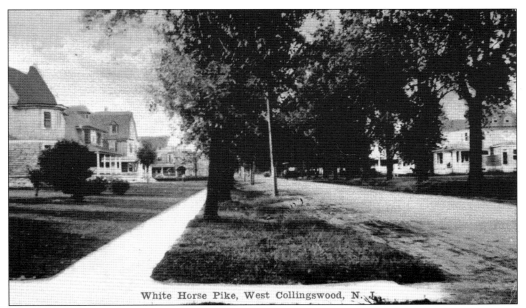

THE WHITE HORSE PIKE, WEST COLLINGSWOOD, C. 1917. This scene gives the impression that West Collingswood is a rapidly growing suburb. The tree-shaded pike is now lined with a succession of generous middle-class houses. Although the sidewalks are paved, it took another five years before the pike was covered with concrete. (Courtesy Collingswood Library.)

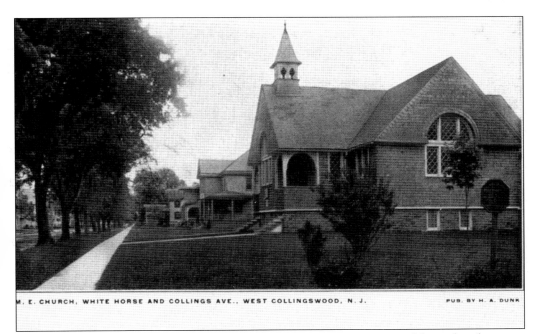

METHODIST EPISCOPALIAN CHURCH, WEST COLLINGSWOOD, C. 1910. Many churches were built along the White Horse Pike. In this photograph, the Methodist Episcopalian Church stands among the residences along the pike at the corner of Collings Avenue. (Courtesy Collingswood Library.)

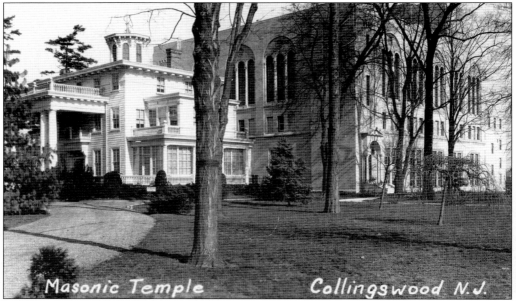

THE MASONIC TEMPLE, WEST COLLINGSWOOD, C. 1930. Do you recognize the house that serves as the entrance to the Masonic Temple at 315 White Horse Pike? It's Dungarvin, the William Hurley residence (see page 72). Since being constructed in 1850, Dungarvin has served as a residence, women's hospital, mental hospital, and finally, the Masonic Temple. (Courtesy Collingswood Library.)

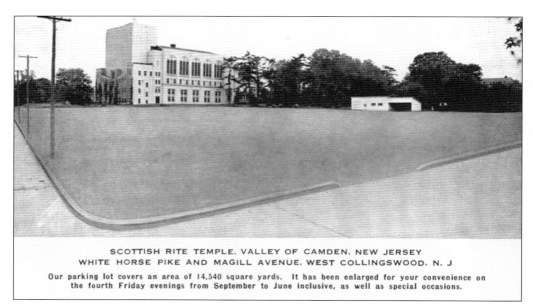

SCOTTISH RITE TEMPLE, WEST COLLINGSWOOD, C. 1940. This photograph provides another perspective, from Magill Avenue, of the temple that was Dungarvin. Note that by this point in history, Americans so loved their automobiles that parking has become a selling point. (Courtesy Collingswood Library.)

**DUNGARVIN ENDURES, WEST COLLINGSWOOD, C. 1960.** Despite the continued growth and modernization of the temple over the years, the original façade of Dungarvin stands as a reminder of West Collingswood's rich history. (Courtesy Collingswood Library.)

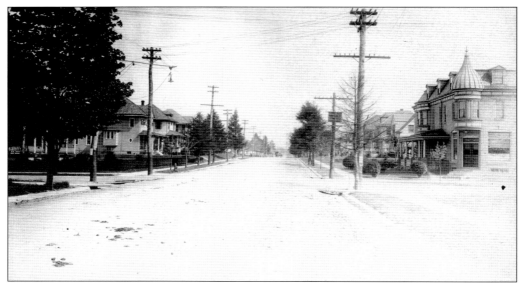

**CORNER OF WHITE HORSE PIKE AND STATION AVENUE, HADDON HEIGHTS, C. 1910.** Growth in Haddon Heights was steady from the time Benjamin Lippincott built a station for passengers on his own land along the Philadelphia and Atlantic Railroad line in 1890. The borough was incorporated in 1904. This view shows the comfortably populated intersection of the two main roads in town. Klein's market is the turreted building on the right. (Courtesy Haddon Heights Library.)

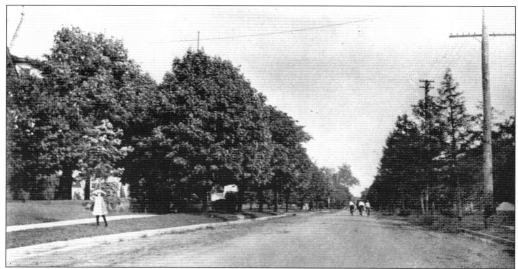

**A SPRINGTIME JOURNEY ON THE PIKE, HADDON HEIGHTS, C. 1915.** Three cyclists enjoy a jaunt eastbound behind a horse-drawn wagon on the scenic White Horse Pike. The little girl is standing near the Lippincott house, the turret of which can be seen at the top left above the trees. (Courtesy Haddon Heights Library.)

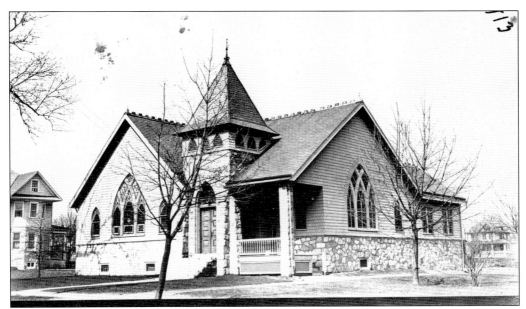

FIRST BAPTIST CHURCH, HADDON HEIGHTS, C. 1913. The First Baptist Church was the first church built in Haddon Heights. It stands across the White Horse Pike from the Crookes residence and next door to where the Evaul brothers did business, at the corner of Station Avenue. Some branches of the famous buttonwood tree can be seen at the extreme left of the photograph. (Courtesy Haddon Heights Library.)

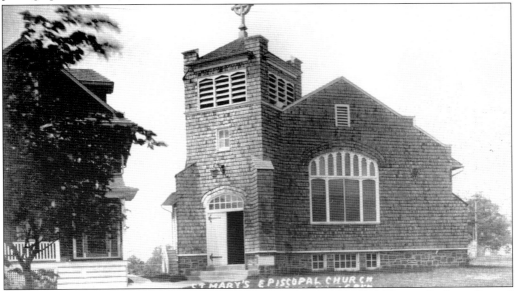

ST. MARY'S EPISCOPAL CHURCH, HADDON HEIGHTS, C. 1913. D. Mason Godwin Sr. and his wife were instrumental in establishing an Episcopal church in Haddon Heights. They held services in their home from 1900 until the original portion of the church was constructed in 1910. Additions to the church were completed in 1936 and 1959. St. Mary's faces Green Street and the Lippincott House. The White Horse Pike runs along the right of the church. (Courtesy Haddon Heights Library.)

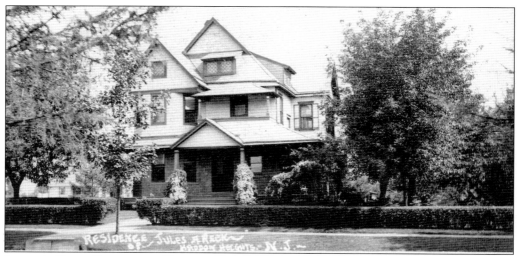

JULES A. RECK RESIDENCE, HADDON HEIGHTS, C. 1910. This view of 119 White Horse Pike captures the house built by F. Fries that later became the residence of Jules A. Reck. The house is typical of those rising in the borough, which appealed to the middle class migrating from the cities. (Courtesy Haddon Heights Library.)

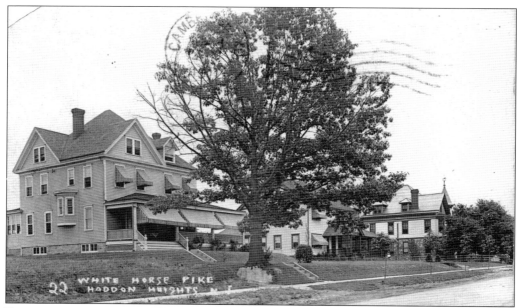

RESIDENCES ALONG THE WHITE HORSE PIKE, HADDON HEIGHTS, 1911. This postcard shows newer construction along the pike. The sender purchased the card at Evaul Brothers and writes, "Do you see me anywhere? We did not know Evaul's had them." (Courtesy Haddon Heights Library.)

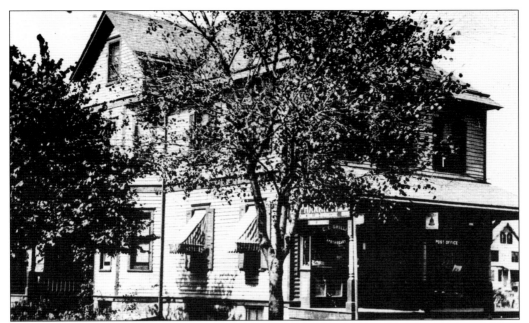

SHILLITO'S APOTHECARY, HADDON HEIGHTS, C. 1940. With a new generation came a new general store. C. E. Shillito opened his business, including the new apothecary, in the building where the Evaul Brothers had done business since 1898, at the corner of the White Horse Pike and Station Avenue. (Courtesy Haddon Heights Library.)

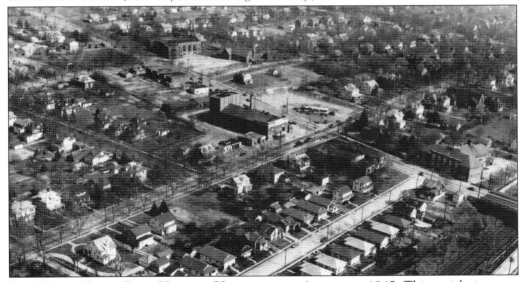

THE WHITE HORSE PIKE, HADDON HEIGHTS, AND AUDUBON, 1945. This aerial view may have captured a preview of traffic congestion to come along the pike, which is the road cutting from the middle left to the top right. The photograph was taken by Conrad G. Merrill. He and his wife, Mary, lived at 730 White Horse Pike in Audubon for more than 50 years. The diner sitting diagonally on its lot (to the top and right of center) is famous for having been destroyed by a tornado that touched down in Haddon Heights in the 1950s. (Courtesy Haddon Heights Library.)

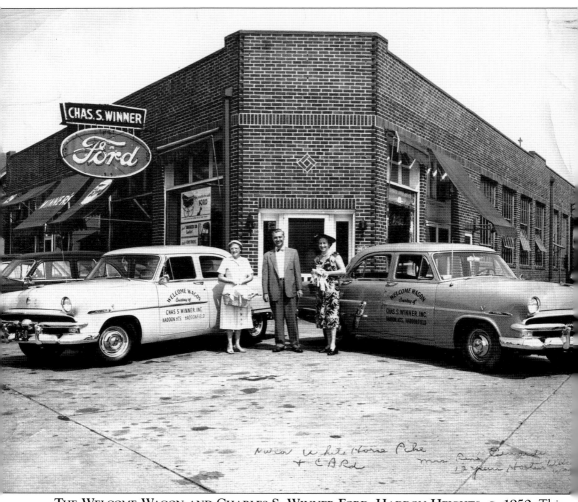

THE WELCOME WAGON AND CHARLES S. WINNER FORD, HADDON HEIGHTS, C. 1950. This showroom, at the corner of the White Horse Pike and Clements Bridge Road, was the first of many Winner Ford dealership locations. From left to right, an unidentified Welcome Wagon hostess, Charles S. Winner, and Rene Edwards, who served as a hostess for 12 years, pose with the new Ford Welcome Wagon cars. (Courtesy Haddon Heights Library.)

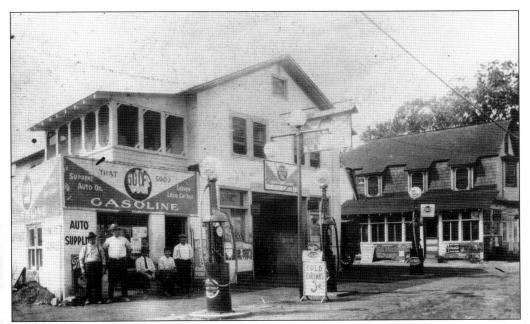

GILMORE'S GARAGE, MAGNOLIA, C. 1920. Gilmore's sold Gulf gasoline and Supreme oil, but the owner knew the real way to attract customers: offer cold drinks to hot motorists. The filling station no longer stands at the White Horse Pike and East Washington Avenue, but a Grease 'N Go occupies the location. (Courtesy Magnolia Historical Society.)

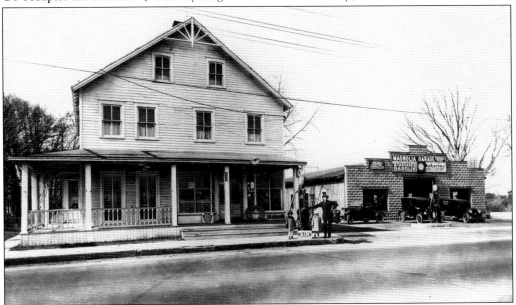

MAGNOLIA GARAGE, T. REINERT, PROPRIETOR, MAGNOLIA, C. 1926. Filling stations and repair shops began to spring up all along the White Horse Pike as soon as automobiles became a popular way to travel. Early model automobiles were not the most dependable conveyances. T. Reinert established his business at 208 North White Horse Pike, where Tom Barrett had his store. (Courtesy R. L. Long.)

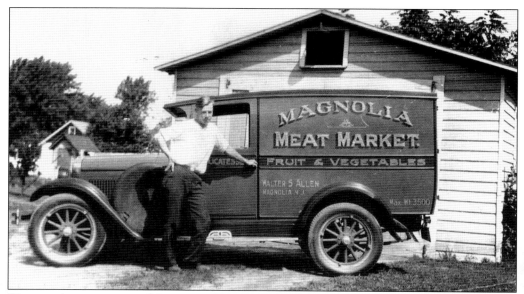

WALTER ALLEN AND HIS MAGNOLIA MEAT MARKET TRUCK, MAGNOLIA, C. 1930. Walter S. Allen appears to be proud of his new truck. The trucking industry grew along with automobile ownership and the ever improving and expanding roadway system throughout the country. Speedy trucks allowed for fresh goods to be delivered quickly to markets in every community center, changing the way people shopped. (Courtesy R. L. Long.)

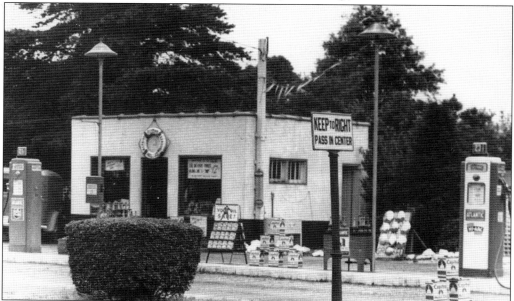

PAULSON'S GARAGE, MAGNOLIA, C. 1949. This photograph of Paulson's Garage, on the White Horse Pike at Monroe Avenue, provides a clear view of the three-lane pike. One lane was designated for each direction, and the third lane, in the middle of the road, was used for passing and turns. As the older photographs of the pike show, its many curves made using the third lane extremely dangerous, particularly as newfangled car engines provided more horsepower. The Magnolia Post Office is located on this spot today. (Courtesy Magnolia Historical Society.)

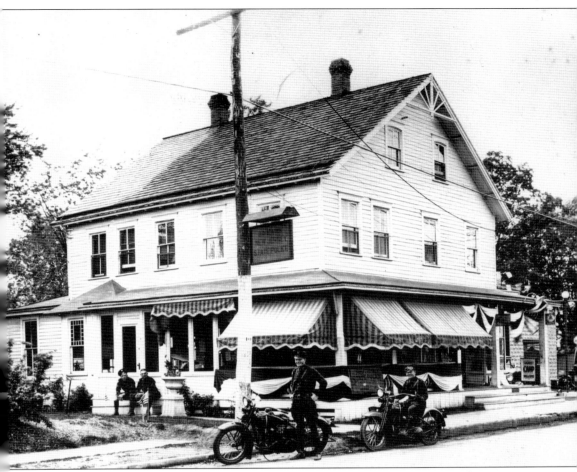

NEW JERSEY STATE POLICE SUBSTATION, MAGNOLIA, C. 1939. These four New Jersey state police officers served in one of New Jersey's 28 substations. The gas pumps and auto repair shop, formerly owned by T. Reinert, are visible at the right. When the New Jersey State Police division was first established in 1921, officers patrolled vast rural areas. Chicken thievery was a huge concern. A poultry-tattooing program, established in 1933, reduced the problem. Automobile theft was also so much a concern that an auto-theft bureau was formed in the 1920s. The bureau recovered 500 stolen vehicles in 1929. In 1930, officers were responsible for upholding the traffic laws for the 800,000 registered vehicles in New Jersey. (Courtesy Magnolia Historical Society.)

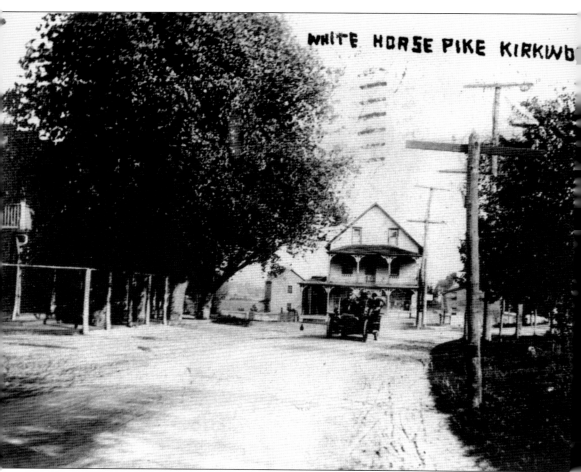

WHITE HORSE PIKE, KIRKWOOD-STRATFORD, C. 1908. In this view from Kirkwood looking east, the White Horse Tavern (left) and general store (center) form the nucleus of what later became the borough of Stratford in 1925. The tavern was built in 1740 and featured a large black sign with the silhouette of a white horse until its demolition in 1950. The White Horse Pike probably takes its name from this tavern. Compare this view of the pike with the photographs that follow. (Courtesy R. L. Long.)

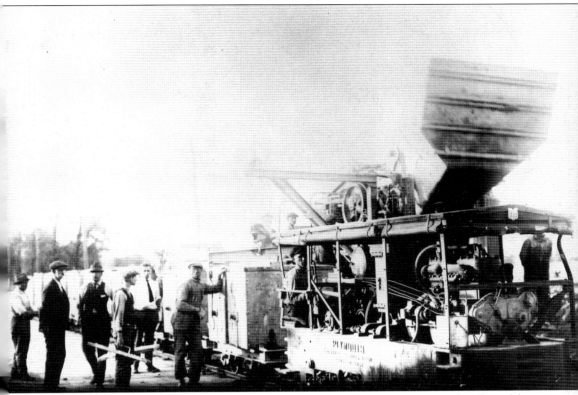

**PAVING THE WHITE HORSE PIKE, STRATFORD, 1922.** Howard D. Oliver operates the Plymouth paver, while a group of engineers and laborers wait to begin work. Suburban development, increasing automobile ownership, and the promise of the Delaware River Bridge made the paving of the White Horse Pike a necessity. Trucks from Camden delivered dry paving mixture to the job site in steel boxes. The boxes were loaded onto flanged wheel carts that the Plymouth paver pulled along the job site railroad. As the crew moved forward, the unused railroad track at the rear was picked up and laid ahead of the paver. (Collection of Joe Murphy, courtesy R. L. Long.)

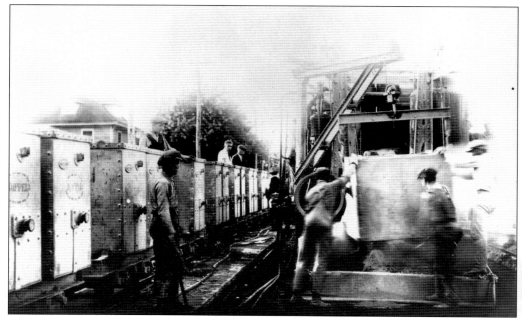

MIXING THE CONCRETE, STRATFORD, 1922. This view of the paving process shows laborers dumping the dry mixture into the scoop. The scoop would then be raised to the top of the Plymouth Paver and dumped into the rotating drum, where it was mixed with water. (Collection of Joe Murphy, courtesy R. L. Long.)

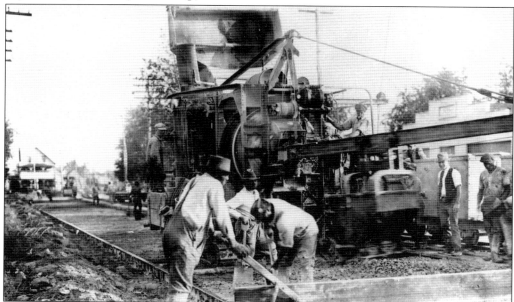

POURING THE CONCRETE, STRATFORD, 1922. Not far from the White Horse Tavern (out of view to the left), laborers prepare the roadbed for the concrete paving mixture. Finished concrete was fed from the rotating drum into a bucket. The bucket rolled along the I-beam protruding from the rear of the Plymouth Paver to deliver the concrete to the proper location. (Collection of Joe Murphy, courtesy R. L. Long.)

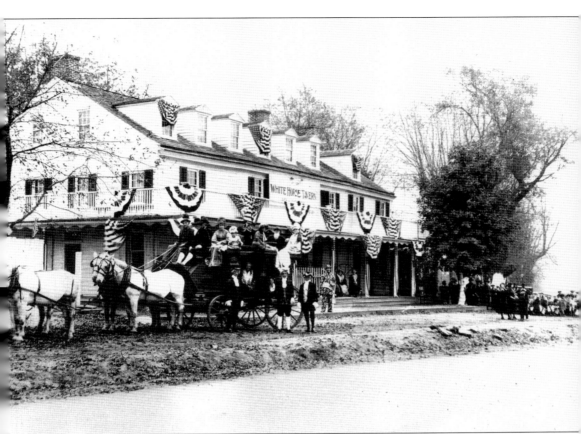

**Townsfolk Celebrate the Opening of the Newly Paved Pike, Stratford, c. 1922.** The paving was truly something to celebrate. Fewer than 100 years before, travelers spent days traversing New Jersey from Camden to Absecon on the rutted road. The White Horse Tavern was a welcome stagecoach stop, a day's journey from the next nearest inn and tavern in either direction. Compare the muddy roadside beneath the stagecoach with the smooth surface of the newly paved White Horse Pike. The tavern also served visitors to Kirkwood Lake, who walked the short distance to partake of the establishment's famous chicken dinners. The tavern is bedecked in patriotic bunting, and an assembly of citizens in Colonial garb has gathered to mark the occasion. (Courtesy R. L. Long.)

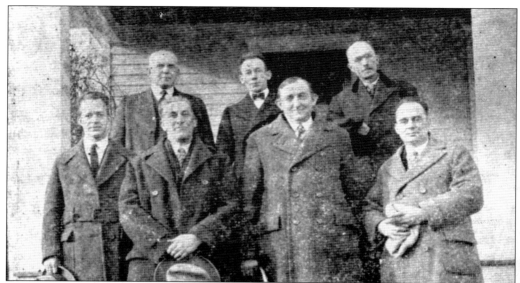

**THE FIRST BOROUGH COUNCIL, STRATFORD, 1925.** Although Stratford's settlement dates to 1740 with the opening of the White Horse Tavern, it was not until 1889 that Charles King purchase land and laid out a plan for streets and building lots. Stratford remained part of Gloucester Township until 1903, when Clementon Township was incorporated. A referendum was held in 1925, and the borough of Stratford was incorporated by a vote of 292 to 5. The first borough council includes, from left to right, (first row) Mr. Heins, Mr. Nicholson, Mayor Royden Lippincott, and Mr. Jones; (second row) Mr. Simpkins, Mr. Cheeseman, and Mr. Matthews. (Courtesy James F. Henry.)

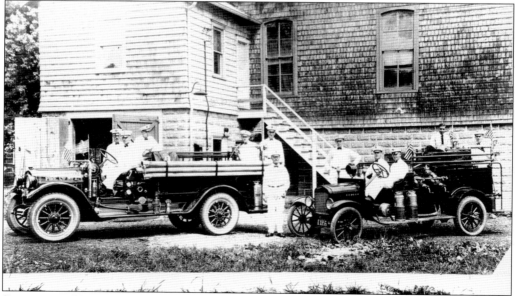

**STRATFORD VOLUNTEER FIRE COMPANY NO. 1, STRATFORD, C. 1925.** The proud men of Stratford's Volunteer Fire Company No. 1 show off their gleaming trucks and pristine uniforms. The company was first organized in 1908, with chief Samuel T. Simpkins. The town hall and firehouse was erected in 1911. (Courtesy R. L. Long.)

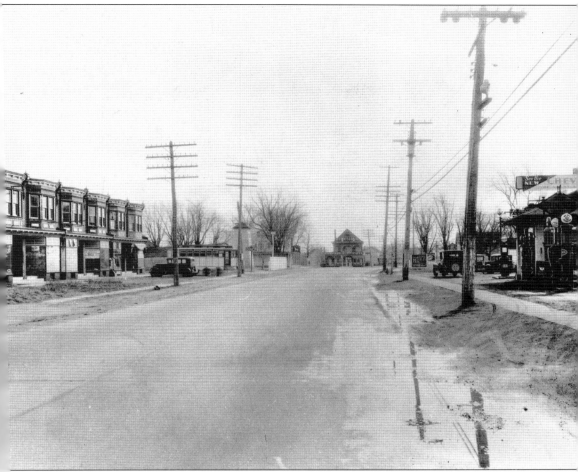

**THE WHITE HORSE PIKE NEAR HARVARD AVENUE, STRATFORD, C. 1931.** The White Horse Tavern (center) continues as a welcome sight for travelers. The Quaker Store is now a gas station and restaurant. New business had sprung up as traffic increased and Stratford's population grew. On the right side of the pike are the Joseph A. Murtra Auto Repair shop and the H. R. Nickelson Chevrolet Agency. The row of shops on the left side of the pike feature a radio shop and a real estate agency. A five-room bungalow with a garage sells for $3,950. (Collection of Joe Murphy, courtesy R. L. Long.)

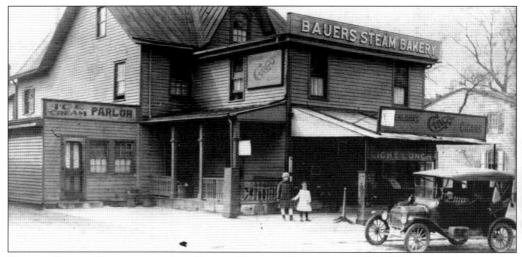

**BAUERS STEAM BAKERY AND ICE-CREAM PARLOR, BERLIN, C. 1920.** Who can resist stopping for ice cream on a long drive to or from the shore? Thanks to Bauers, when the weather was too cold for ice cream (as it might have been in this photograph), steam-baked goodies satisfied a traveler's sweet tooth. (Courtesy Borough of Berlin.)

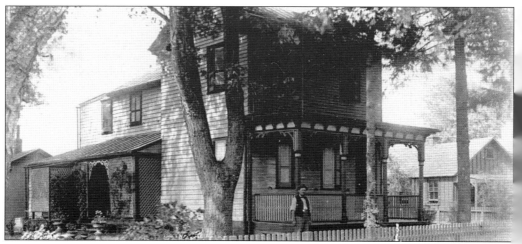

**A RESIDENCE ON THE WHITE HORSE PIKE, BERLIN, C. 1920.** Berlin did not develop as a commuter suburb. Residences were not of the grand size seen in towns such as West Collingswood and Haddon Heights. Nonetheless, Berlin's residents built attractive houses. (Courtesy Borough of Berlin.)

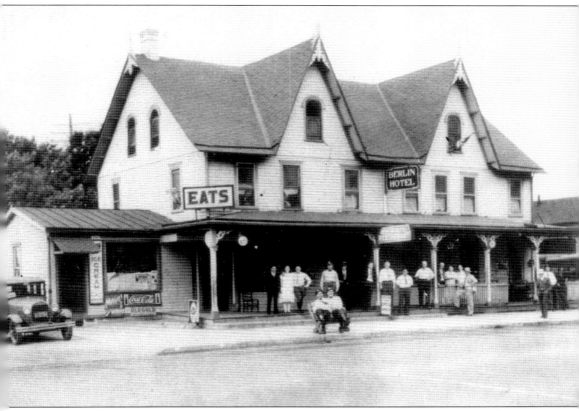

**THE BERLIN HOTEL, C. 1925.** Times are changing for the Berlin Hotel. Those who travel the newly paved White Horse Pike by car may no longer need to stay the night; rather, they need a quick break. The "Eats" sign announces that the hotel is a good place to stop, perhaps even for ice cream. Gone are the porch-front trees, the hitching post, and the wooden roadside sign. The Berlin Hotel building served in several capacities until it was closed in 1995. The citizens of Berlin have saved the building from destruction, although they were forced to move it in order to so do. (Courtesy Borough of Berlin.)

A FORK IN THE ROAD, BERLIN, C. 1915. The White Horse Pike leads straight forward to Atlantic City. Blue Anchor Road (now Tansboro Road) veers off to the right. The Peter Ross-Louis Health Store (center) served as a recruiting station for Company H, 28th Regiment, New Jersey Volunteers at the time of the Civil War. (Courtesy the *Courier-Post*.)

A NEW AND IMPROVED FORK IN THE ROAD, BERLIN, C. 1925. The Peter Ross-Louis Health Store remains at the fork of the White Horse Pike and Blue Anchor Road, but this intersection is undergoing other changes. Traffic is increasing, bus service has been instituted, houses are lining the wide boulevards, trees are disappearing, and the ubiquitous gas station has been established (far right). (Courtesy Borough of Berlin.)

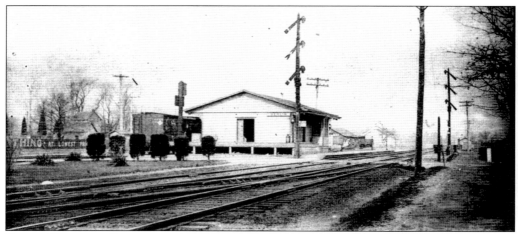

BERLIN RAILROAD STATION, C. 1925. Little has changed at the borough's train station since the beginning of the 20th century. Riding bicycles on the platform remains forbidden. Shrubbery has been planted to the left of the station house. (Courtesy Borough of Berlin.)

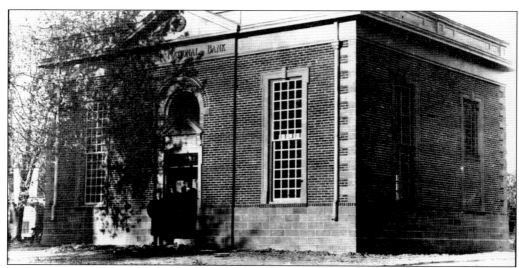

BERLIN NATIONAL BANK, C. 1915. The Berlin National Bank first opened its doors in Elmer E. Stafford's general store on August 1, 1910. Construction of the permanent bank building pictured here had not yet been finished. When the bank did open for business several months later, customers enjoyed approaching the front door on poured concrete sidewalks, the first such sidewalks in Berlin. (Courtesy Borough of Berlin.)

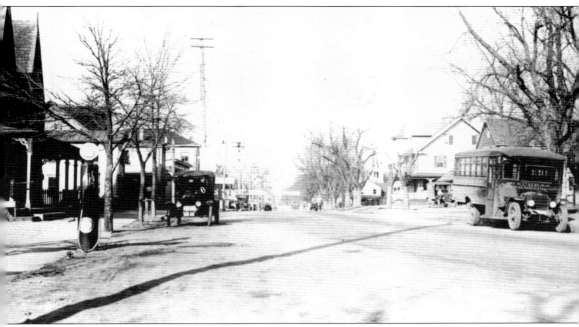

WHITE HORSE PIKE, BERLIN, 1922. This view north along the White Horse Pike shows both the pike and Berlin's development. Residences and business are closer together. Traffic is evident, and bus service has begun. The bus at the right of the photograph is a McLaughlin, Mackler, Gasior. Destinations indicated on the front of the bus include Camden, Berlin, Magnolia, and the Pennsylvania Railroad Ferry. (Courtesy Borough of Berlin.)

**STAMPER'S BUS AND DRIVER, BERLIN, C. 1930.** The shift from road travel to rail travel to road travel is coming full circle by this time. Trolley service officially ended in 1935, and rail ridership was steadily decreasing, although service did not come to a complete stop until the 1980s. (Courtesy Borough of Berlin.)

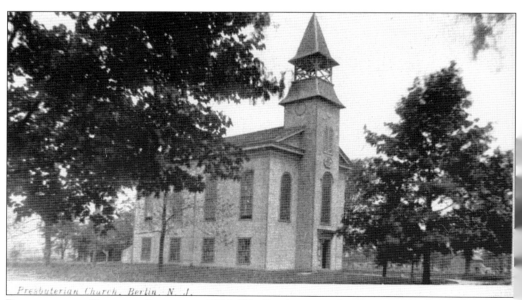

**PRESBYTERIAN CHURCH, BERLIN, C. 1920.** The Presbyterian church was one of several churches to rise in Berlin around the beginning of the 20th century. (Courtesy Borough of Berlin.)

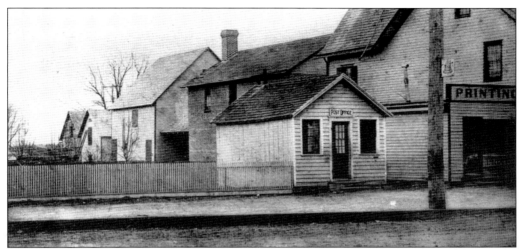

POST OFFICE, BERLIN, C. 1920. This tiny post office building served the population of Berlin until the new building was erected in 1961. Before Elmer Stafford opened E. E. Stafford's General Store, he was appointed postmaster by Pres. Benjamin Harrison. He served two terms, from 1890 to 1894 and 1899 to 1902. (Courtesy Borough of Berlin.)

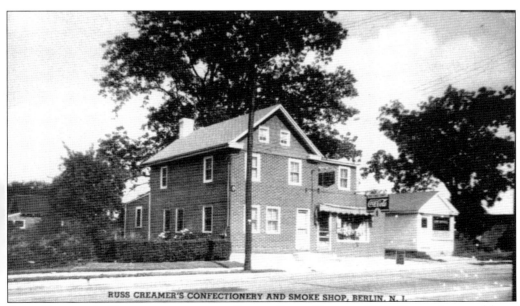

RUSS CREAMER'S CONFECTIONERY AND SMOKE SHOP, BERLIN, 1945. Fancy signs and large parking lots had not yet defined the convenience store. Russ Creamer's had everything a traveler could want: sweets, Coca-Cola, and tobacco products. (Courtesy Borough of Berlin.)

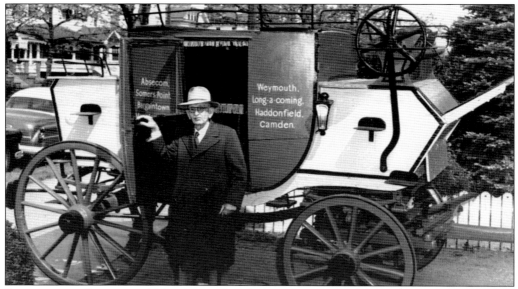

STAGECOACH, BERLIN, C. 1950. An unidentified gentleman stands before a restored stagecoach in Berlin. In such tight quarters, the days-long trip between Camden and the shore must have seemed even longer. Note the lantern near the door and the names of its destinations. This stagecoach would have crossed the White Horse Pike in Long-a-Coming (Berlin), but would have traveled along the Long-a-Coming Road (now Route 561) through Haddonfield and on to Camden. (Courtesy Borough of Berlin.)

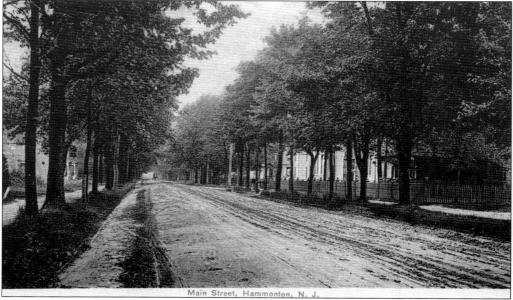

MAIN STREET, HAMMONTON, C. 1920. Improvements to the White Horse Pike (Main Street) must have been welcome to the citizens of Hammonton. Although a scenic route through town, the mud and ruts appear to make for a rough ride. The government began its federal route-numbering program in 1925, making the road from Camden to Atlantic City uniform as U.S. Route 30. (Courtesy Ann and Bob Tomasello.)

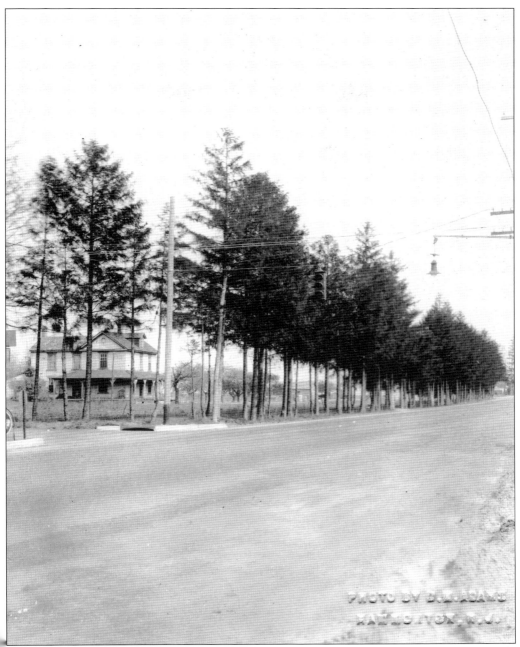

THE HENRY M. PHILLIPS FARM, HAMMONTON, C. 1930. Development begins to encroach upon the Phillips farm on the White Horse Pike at Middle Road. The pike has been widened and paved. Traffic had increased enough to warrant the installation of a traffic signal at this intersection. A Gulf station occupies the corner across from the farm. The farm did not survive. Today it is the site of a fast-food restaurant, a grocery store, and a discount superstore. (Courtesy Ann and Bob Tomasello.)

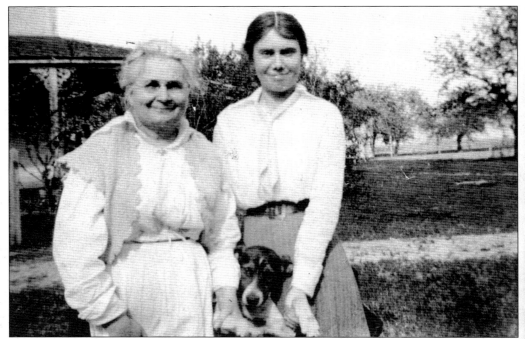

**LIFE ON THE PHILLIPS FARM, HAMMONTON, C. 1915.** Behind the row of trees defining the Phillips farm, work is interrupted to pose for a photograph with the family dog. Pictured are Henry Phillips's half-sister, Pauline Robinson (left), and his daughter Anna C. Phillips. (Courtesy Ann and Bob Tomasello.)

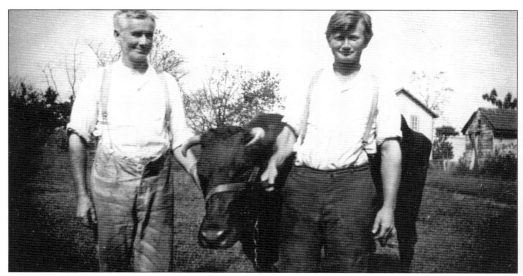

**A PAUSE FROM FARMWORK, HAMMONTON, C. 1915.** Henry Phillips (left) and his son, Charles M. Phillips, show off a young bull. After college, Charles Phillips left the farm to attend law school and embark on a long career in public service. (Courtesy Ann and Bob Tomasello.)

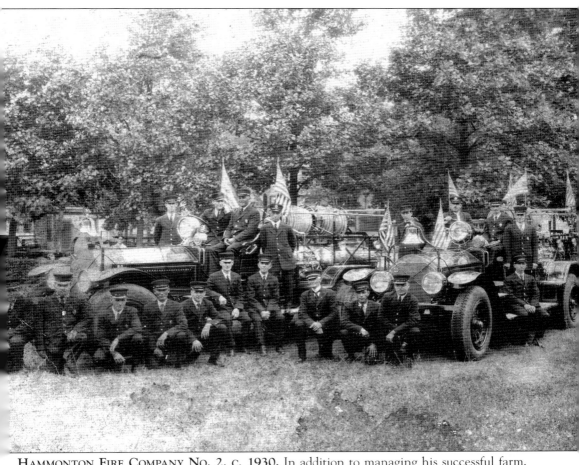

HAMMONTON FIRE COMPANY NO. 2, c. 1930. In addition to managing his successful farm, Henry M. Phillips served as Hammonton's Fire Chief for 50 years. He is kneeling, third from the right, in front of the trucks. (Courtesy Ann and Bob Tomasello.)

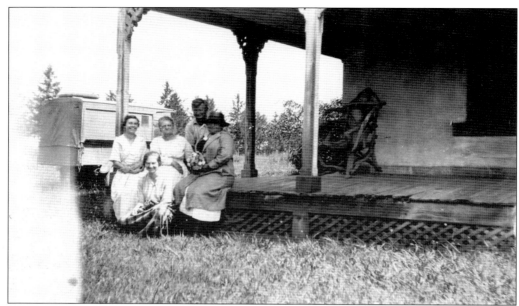

THE PHILLIPS FAMILY WELCOMES A VISITOR, HAMMONTON, C. 1930. From left to right are daughters Anna C. and Pauline, wife Emily, son Charles M., and their unidentified visitor. Charles Phillips married Emily Morris of Camden, who was Walt Whitman's neighbor and who sat on the poet's lap as a child. (Courtesy Ann and Bob Tomasello.)

HENRY M. PHILLIPS, HAMMONTON, C. 1935. Henry Phillips was a prominent citizen of Hammonton for many years. He served the community well, both with his farmland and his duty as fire chief. He educated all of his children, including his daughters, which was not common at this time in history. Daughter Pauline was president of her graduating class at Drexel University. (Courtesy Ann and Bob Tomasello.)

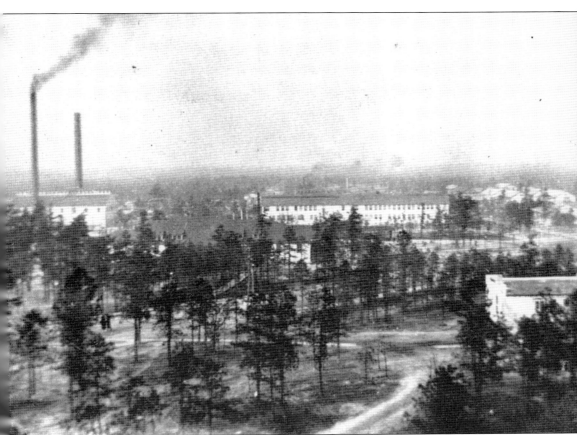

**AMATOL SHELL LOADING FACTORY AND COMPANY TOWN, C. 1920.** The Amatol Shell Loading Factory and company town were built on the White Horse Pike four miles east of Hammonton in response to the need for munitions during World War I. Construction was swift and well planned for both safety and aesthetics. Design dictated that if an explosion occurred in one building, it would not affect the others. Safety measures included placement of hydrants, hoses, and fire buckets at each building and powerful exhaust systems. Regular inspections of the water lines were conducted. Special patrols removed TNT dust and factory waste. (Courtesy Ann and Bob Tomasello.)

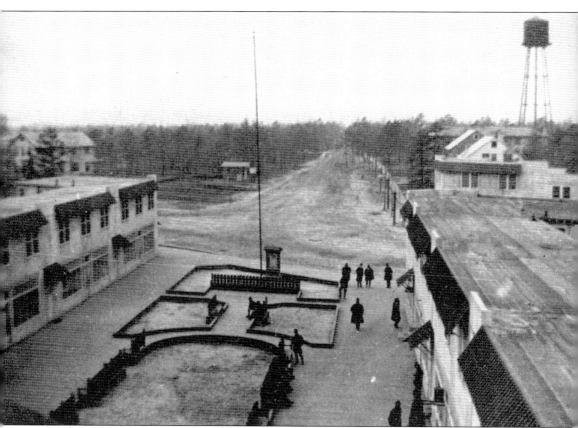

EMPLOYEE QUARTERS, AMATOL, C. 1920. For safety purposes, employees lived two miles away from the factory buildings. Amatol employees loaded shells of all sizes, from hand grenades to 75-millimeter drop bombs. The newest production methods and measures were established in the factory. Conveyor belts moved shells along an assembly line to save time and energy. Shells were loaded with a mixture of amatol and TNT. The factory and town disappeared as quickly as it was constructed. All that remains today is the former New Jersey State Police Barracks on the White Horse Pike in Hammonton. The site has been reclaimed by the forest. (Courtesy Ann and Bob Tomasello.)

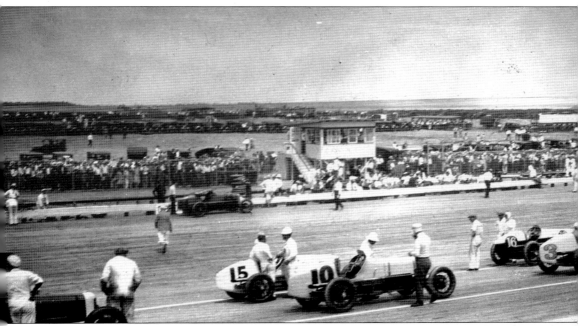

ATLANTIC CITY SPEEDWAY (AMATOL RACE TRACK), MULLICA TOWNSHIP, C. 1930. The Atlantic City Speedway rose from a portion of the Amatol Shell Loading Factory site in 1926. The 50-foot-wide, 1.5-mile-long wooden track was constructed of 4.5 million board feet of hemlock and spruce. Speeds of 160 miles per hour were attainable, and the track was briefly billed as better than the Indianapolis 500. The grandstand seated 60,000, and space was available for 250,000 to stand. Attendance for the inaugural race overwhelmed the site. The 60,000-vehicle parking lot was jammed, and hundreds more parked along the White Horse Pike. Subsequently, the Pennsylvania Railroad instituted special train service to the track. An oval dirt track, hidden by thick underbrush and forest, is all that remains of the Atlantic City Speedway today. (Courtesy Ann and Bob Tomasello.)

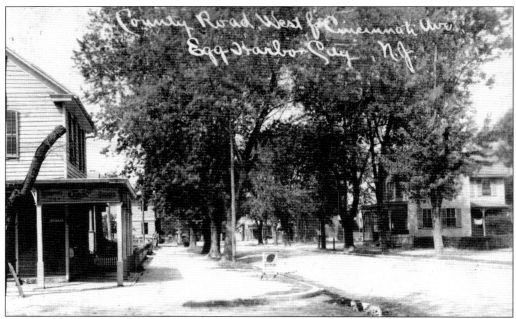

WHITE HORSE PIKE AND CINCINNATI AVENUE, EGG HARBOR CITY, C. 1925. The view west along White Horse Pike (County Road) may not distinguish Egg Harbor City from other pike towns, but Egg Harbor City's industrial makeup did. The sandy soil, warm summer temperatures, and determination of its German settlers to grow good wine grapes added up to a profitable industry for the town. (Courtesy Egg Harbor City Historical Society.)

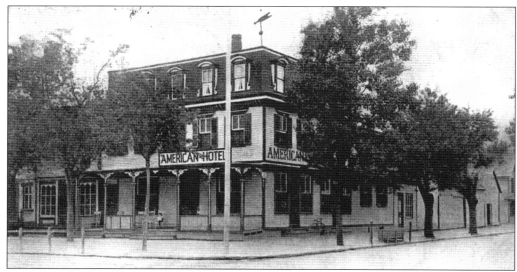

AMERICAN HOTEL, EGG HARBOR CITY, C. 1920. Guests at the American Hotel, nicknamed the Golden Ox, had a wonderful view of the main intersection in Egg Harbor City, the White Horse Pike (Agassiz Street), and Philadelphia Avenue. Sadly, the hotel was replaced with a modern doughnut shop. (Courtesy Egg Harbor City Historical Society.)

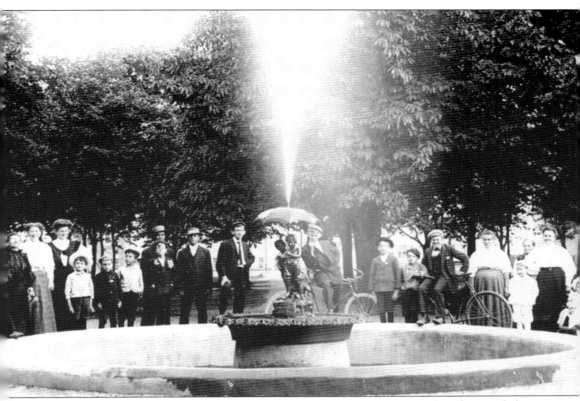

**LINCOLN PARK FOUNTAIN, EGG HARBOR CITY, 1915.** Townsfolk have gathered around the city fountain to pose for this picture postcard. Lincoln Park, first named Excursion Park, was renamed in 1905 at Egg Harbor City's 50th anniversary celebration in honor of Pres. Abraham Lincoln. Soon after this photograph was taken, the fountain was dismantled and stored in a private barn. When the Egg Harbor City Historical Society was founded in the 1990s, the fountain was restored to a new base of river rock next to the Roundhouse Museum, the site of Dr. Smith's Neutral Water Health Resort. (Courtesy Egg Harbor City Historical Society.)

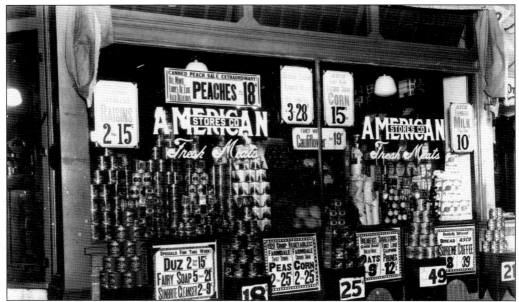

AMERICAN STORE, EGG HARBOR CITY, C. 1925. Look at those prices! We know the American Stores Company as Acme Markets today. This early grocery store was located on the northern corner of the White Horse Pike (Agassiz Street) and Philadelphia Avenue. Several stores have occupied this building including a drugstore, a beauty salon, and a cellular telephone store. (Courtesy Egg Harbor City Historical Society.)

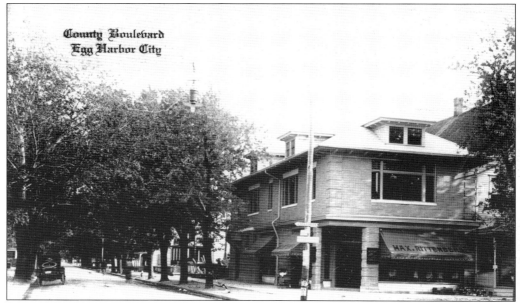

COUNTY BOULEVARD AND PHILADELPHIA AVENUE, EGG HARBOR CITY, C. 1918. This early view from the American Store shows the narrow, sparsely traveled White Horse Pike (County Boulevard) at Philadelphia Avenue. Max Rittenberg's Dry Goods store anchors the corner on the right. The baby carriage under the awning to the left of Rittenberg's main entrance is a Bloch Go-Cart, manufactured in Egg Harbor City. (Courtesy Egg Harbor City Historical Society.)

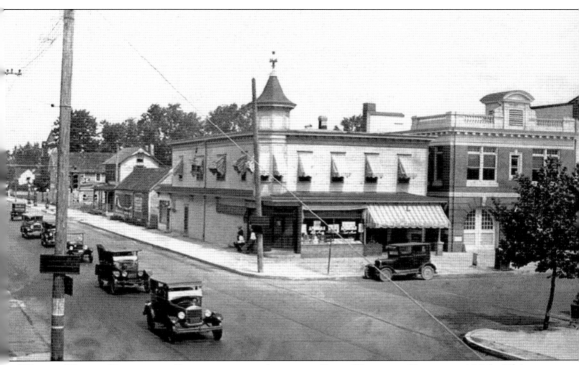

**WHITE HORSE PIKE AND PHILADELPHIA AVENUE, EGG HARBOR CITY, C. 1924.** This photograph was taken from Max Rittenberg's store looking across to the American Store. The White Horse Pike has been widened and paved, and automobiles have replaced bicycles as the common mode of transportation. In fact, traffic has become heavy enough to warrant the installation of Egg Harbor City's only traffic light (directly above the third car from the bottom). The American Store building still stands today, minus its cupola. The other buildings have been razed. (Courtesy Egg Harbor City Historical Society.)

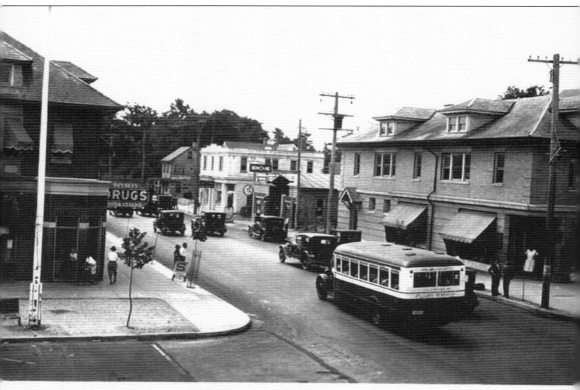

White Horse Pike, Egg Harbor City, N. J.

U.S. ROUTE 30 AND PHILADELPHIA AVENUE, EGG HARBOR CITY, 1928. This later view from the American Store looking toward Lincoln Park shows heavy traffic on the widened and paved White Horse Pike (now U.S. Route 30). Dr. Boysen's Rexall Pharmacy stands on the left corner. Max Rittenberg's store is across the pike on the right (with awnings). Each business changed hands several times. Boysen's is now a large chain drugstore, and a gas station occupies the large Rittenberg space. Of the buildings pictured here, only the white building at the center remains today. (Courtesy Egg Harbor City Historical Society.)

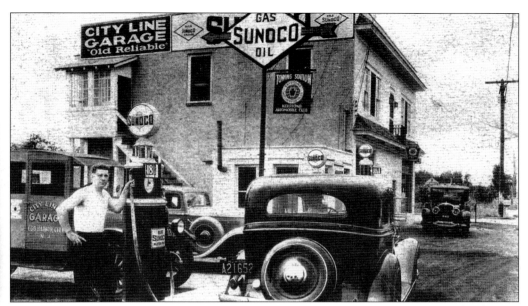

CITY LINE GARAGE, EGG HARBOR CITY, 1934. Owner Julius Garnich appears to be doing a brisk business of pumping gas and repairing automobiles at the corner of White Horse Pike and Hamburg Avenue. (Courtesy Egg Harbor City Historical Society.)

FRONT ENTRANCE OF PUBLIC SCHOOL NO. 1, EGG HARBOR CITY, 1940. Public School No. 1, on the White Horse Pike at Chicago Avenue, has been expanded yet again. A third section for black students was built around 1913 and contained four large classrooms for kindergarten through eighth grade. High school classes were integrated. (Photograph by Thomas Hamlin, Courtesy Egg Harbor Historical Society.)

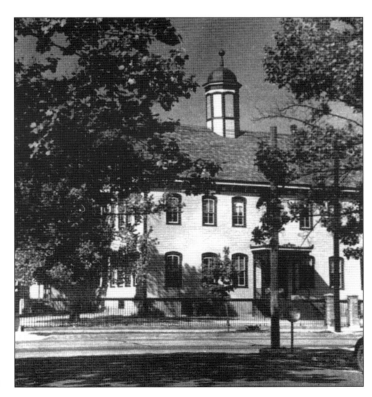

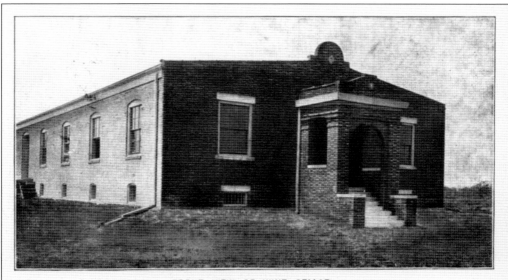

FRONT VIEW OF WINE CELLAR.
THE ATLANTIC VINEYARD & WINE CO., Vineyards and Cellars, Egg Harbor N. J.

ATLANTIC VINEYARD AND WINE COMPANY, EGG HARBOR CITY, C. 1940. Winemaking had been an important source of income for Egg Harbor City since the 1870s. Egg Harbor wines won medals at the Philadelphia Centenary Exhibition in 1876, and in the Paris Wine Exhibition in 1878. The Atlantic Vineyard and Wine Company building is now vacant. (Courtesy Egg Harbor City Historical Society.)

RENAULT WINERY BOTTLE AND PLANT, EGG HARBOR CITY, C. 1945. The bottle in front of the White Horse Pike bottling plant marks the Renault Winery. Renault has been making wine and champagne continuously since 1870, which makes it one of the longest producing wineries in the country. Production thrived even during Prohibition, when Renault produced wines for religious and medicinal purposes. (Courtesy Egg Harbor City Historical Society.)

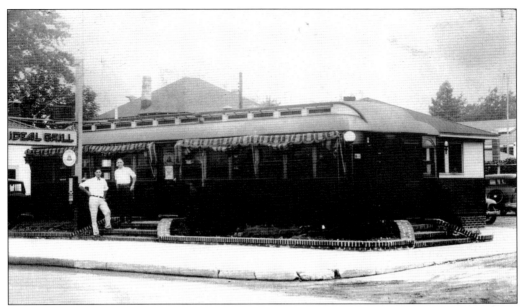

IDEAL GRILL, EGG HARBOR CITY, C. 1930. Charles Kuehnle opened the Ideal Grill in 1928 on this prime location along White Horse Pike between Liverpool Avenue and Fifth Terrace. The diner predates the sleek silver diners of the post–World War II era, but it is certain that Kuehnle upheld the goal of all diner operators who aimed to provide customers with a good, inexpensive home-style meal in comfortable surroundings. (Courtesy Egg Harbor City Historical Society.)

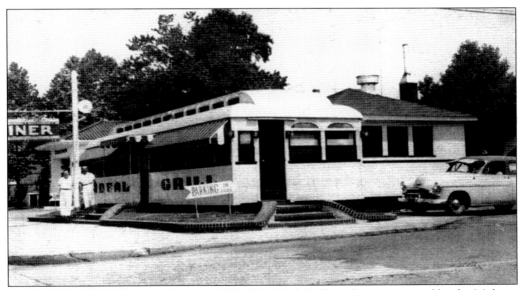

IDEAL DINER, EGG HARBOR CITY, C. 1955. The Ideal Grill, at this time owned by the Molasso family, has undergone a face-lift and has become the Ideal Diner. As with the Masonic Temple in West Collingswood, parking lots are good advertising points. (Courtesy Egg Harbor City Historical Society.)

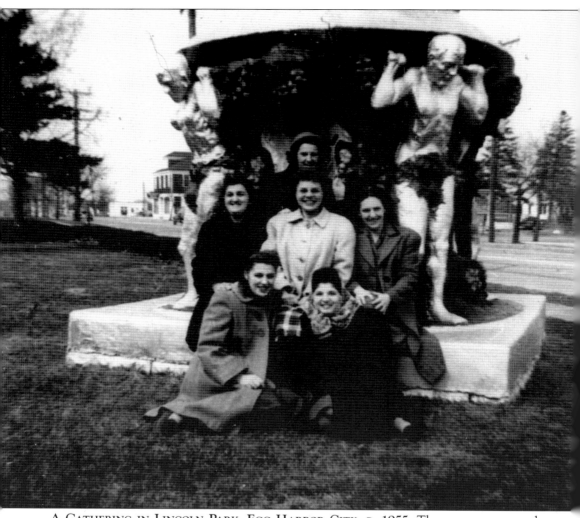

A GATHERING IN LINCOLN PARK, EGG HARBOR CITY, C. 1955. These young women have gathered beneath a monument in Lincoln Park across Buffalo Avenue from Public School No. 1. (Courtesy Egg Harbor City Historical Society.)

**White Horse Pike before Lighting, Absecon, c. 1930.** A night drive along the White Horse Pike (Route 43) from Absecon to Atlantic City was dark and dangerous. Oncoming headlights appear to be blinding, and the few incandescent overhead lights do little to illuminate the roadway. Compare this photograph to the one that follows. (Courtesy John Polillo.)

**White Horse Pike after Lighting, Absecon, c. 1935.** The difference is clear: sodium vapor lighting made a significant difference in the safety of travel along the White Horse Pike. Before the lights were installed, it was nearly impossible to see cars parked along the side of the road or to read the White House Diner's sign for 50-cent fried chicken dinners. (Courtesy John Polillo.)

SODIUM VAPOR LIGHTS ALONG THE WHITE HORSE PIKE, ABESCON, C. 1938. In this last view east on the White Horse Pike, the proliferation of billboards is noted. The high-powered streetlights improved not only night driving safety but also the ability to read the advertisements. (Courtesy John Polillo.)

REPAIRS ALONG THE WHITE HORSE PIKE, ABSECON, C. 1945. No, it is not an early form of road rage. This unidentified gentleman is on official business as an employee of the Atlantic City Electric Company. Note that the White Horse Pike has been marked with the identifiable shield of U.S. Route 30. (Courtesy John Polillo.)

# Five

# ATLANTIC CITY A GENERATION LATER

A mere generation had passed since Walt Whitman observed the vista of Atlantic City's seashore, and the resort town boomed beyond Dr. Pitney's wildest dreams. Massive hotels, amusement piers, shops of all sorts, a broad and permanent boardwalk all contributed to and served the needs of the increasing number of tourists.

Atlantic City reveled in its heyday, but the good times were not to last. The stock market crashed. The world went to war for a second time. Few traveled. Automobile production halted. Atlantic City languished but did not die.

Buoyed by the Miss America pageant and a steady but greatly reduced tourist trade, Atlantic City reinvented itself in 1976 when the Casino Gambling Referendum was passed. The city's status as a favorite playground has been preserved.

The images in this chapter capture Atlantic City before its fall, a time when Atlantic City was truly the world's favorite playground.

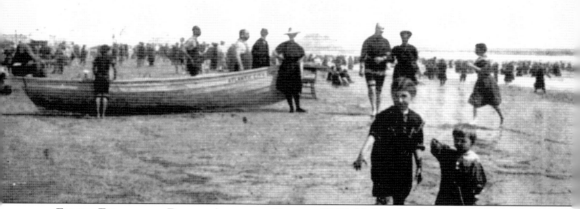

**FAMILY FUN AT THE BEACH, ATLANTIC CITY, C. 1900.** Unlike the playground of the wealthy in Newport, Rhode Island, Atlantic City has always been an accessible destination for the middle class. Railroads and new highways like the White Horse Pike made travel easy and relatively inexpensive for the populations of New Jersey, Philadelphia, and New York. The whole family could vacation in Atlantic City, as is evident in this view. (Author's collection.)

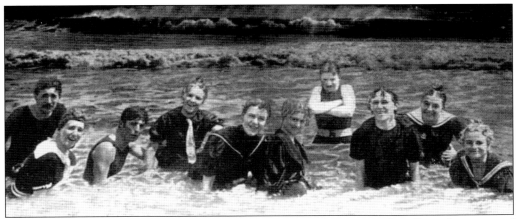

A HEALTHY DIP IN THE OCEAN, ATLANTIC CITY, C. 1910. Dr. Jonathan Pitney's mission of developing a health resort along the barren Atlantic City beach is coming to fruition. This group of young men and women appear to be in the prime of health. (Author's collection.)

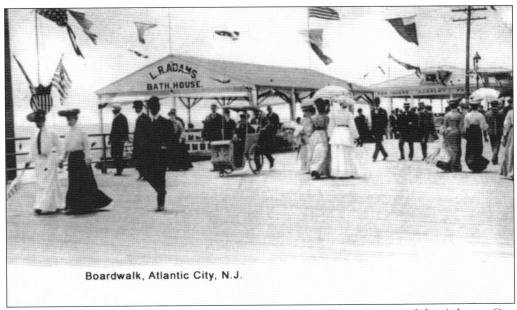

STROLLING THE BOARDWALK, ATLANTIC CITY, C. 1910. The invention of the Atlantic City boardwalk (1870) was a godsend in several ways. First, it accomplished its task of reducing the amount of sand that visitors tracked into the beach-side hotels and even onto the trains; second, it made strolling and window shopping a pleasant task, particularly given the fashions of the day; and third, it precipitated the invention of the rolling cars (1884). When one wearied of walking in the hot summer sun, a comfortable rolling car was not too far away. (Author's collection.)

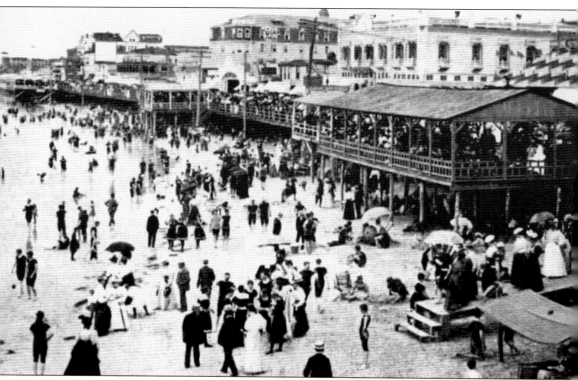

**A Crowded Beach, Atlantic City, c. 1910.** The popularity of Atlantic City exceeded everyone's expectations. More and more luxurious hotels rose along the shore's edge. Amusement piers offered entertainment of every sort. Saltwater taffy satisfied a tourist's sweet tooth. The fresh air, beaches, shops, and entertainment combined to attract visitors—in huge numbers—from all over the world. (Author's collection.)

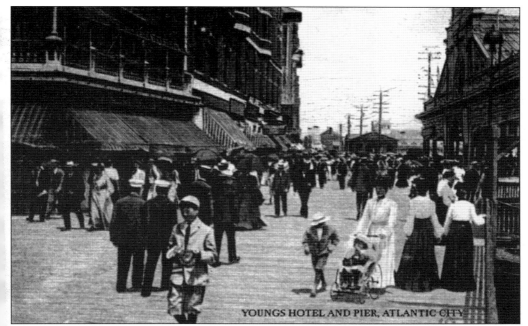

Young's Hotel and Pier, Atlantic City, c. 1910. The amusement piers and boardwalk shops offered a variety of entertainment at any time of day or night. Atlantic City offered more than sun, fun, and shopping. Hunting and fishing expeditions were available for the sporting men who visited. (Author's collection.)

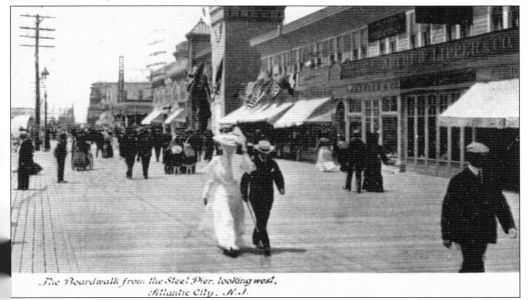

View West from the Steel Pier, Atlantic City, c. 1910. The amusement piers, with names like Million Dollar, Steel, and Iron, were a major attraction. Diving horses, freak shows, music, and games—the piers offered something for everyone. By the mid-20th century, tourism revenues were counted in the hundreds of millions of dollars in Atlantic City and other south Jersey Shore resorts. (Author's collection.)

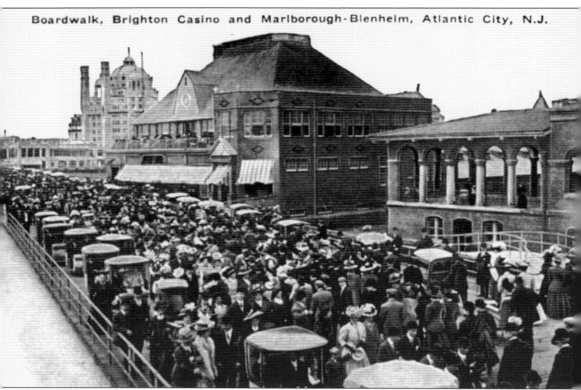

**PEDESTRIAN TRAFFIC ON THE BOARDWALK, ATLANTIC CITY, C. 1910.** Unseasonable weather may have kept bathers off the beaches, but it drove them right onto the boardwalk. Off-season crowds were a delight for hotel and amusement owners, who had always struggled with means to extend the tourist season beyond the hot summer months. (Author's collection.)

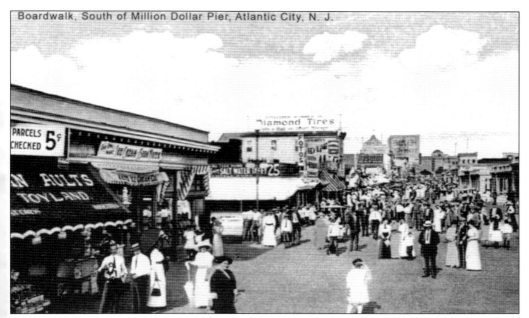

VIEW SOUTH OF THE MILLION DOLLAR PIER, ATLANTIC CITY, C. 1915. There are no more diving horses. The grand old hotels are gone; glittering casinos tower in their place. But along today's six-mile-long boardwalk, one will still find saltwater taffy, ice cream, toys, and a variety of attractions. (Author's collection.)

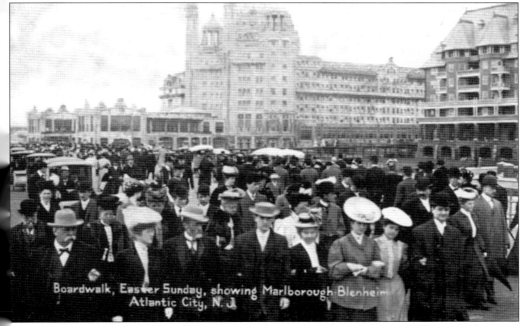

EASTER CROWDS ALONG THE BOARDWALK, ATLANTIC CITY, C. 1915. Throngs of visitors donned their Sunday best to stroll along the boardwalk. The Marlborough-Blenheim was one of many grandiose hotels dotting Atlantic City's shores in the early 20th century. The hotels' size and amenities were attractions in themselves. (Author's collection.)

**HORSEBACK RIDING ON THE BEACH, ATLANTIC CITY, C. 1920.** This sight was common when Walt Whitman traveled to Atlantic City in 1878. Horseback riding remained permitted on the beaches until well into the 1950s. (Author's collection.)

**BATHERS AT ATLANTIC CITY, C. 1920.** The Roaring Twenties ushered in an era of risqué fashion, particularly in women's bathing costumes. Just a year earlier, this woman might have worn a full-coverage wool costume, complete with stockings and shoes. (Author's collection.)

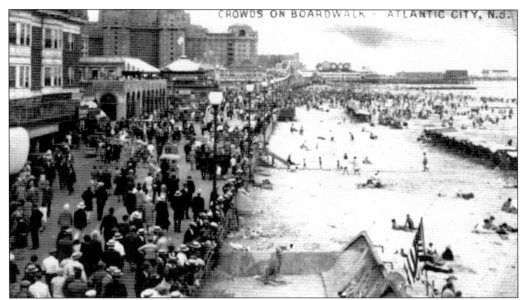

THE BOARDWALK STILL THE RAGE, ATLANTIC CITY, C. 1925. Fashions may have been changing, but the attraction to Atlantic City stayed in style. The city remained a playground for the rich and not-so-rich, as Hollywood's stars began to entertain on the piers. (Author's collection.)

BEFORE THE CRASH, ATLANTIC CITY, C. 1935. The end of Atlantic City's glamour era was fast approaching. In the wake of the stock market crash of 1929, with the impending World War II, and with the postwar age of air travel, Atlantic City lost its image as the world's favorite playground. (Author's collection.)

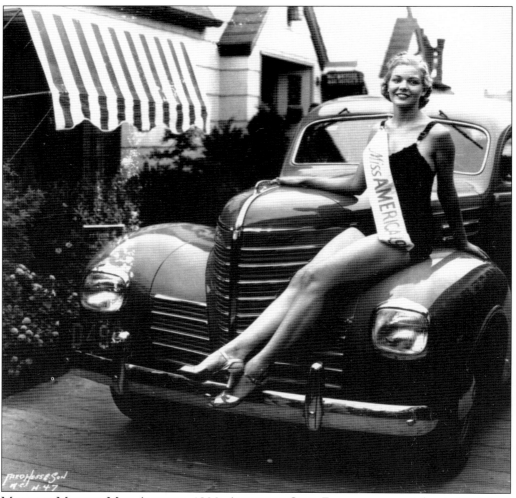

**MARILYN MESEKE, MISS AMERICA 1938, ATLANTIC CITY.** For many years, Atlantic City's best attraction was the annual Miss America Pageant. Marilyn Meseke of Marion, Ohio, was crowned in 1938 and paused in her duties to show off her winning smile. Her crowning was the first to be captured on newsreels, and it is estimated that half the nation watched her triumph. But the pageant alone could not save Atlantic City. The Casino Gambling Referendum, passed in 1976, was instrumental in returning Atlantic City's status as playground for the world. (Courtesy Princeton Antiques.)

# *Six*
# What the Future Holds

Towns up and down the pike are dedicated to the preservation of their historic buildings in spite of the increasingly deep pockets of corporate America. The citizens of Stratford successfully saved the Quaker Store from an oil giant's wrecking ball but must be satisfied that the historic building stands too close to a modern gas station. Those in Berlin took on a large chain of drugstores. They saved the Berlin Hotel but had to move it to make way for the company's newest store. The solutions may not be ideal, but they are successes.

Many towns have active historical societies served by volunteers dedicated to preserving buildings, documents, and photographs. Eight towns are now working together to revitalize areas along the White Horse Pike. In addition to niche business, housing developments are under consideration at key points. Most important, the rich history of each of the towns is at the forefront of planning.

Whatever development the future holds, the White Horse Pike remains the most direct route from city to shore and boasts centuries of history. It appears it will remain a well-traveled path for centuries more.

# Bibliography

Chalmers, Kathryn H. *Down the Long-a-Coming.* Moorestown, New Jersey: the News Chronicle, 1951.

Cranmer, H. Jerome. *New Jersey in the Automobile Age: A History of Transportation.* Princeton, New Jersey: D. Van Nostrand Company, 1964.

Dorwart, Jeffery M. *Camden County, New Jersey: The Making of a Metropolitan Community, 1626–2000.* New Brunswick, New Jersey: Rutgers University Press, 2001.

Dorwart, Jeffery M. and Philip English Mackey. *Camden County, New Jersey 1616–1976.* Camden, New Jersey: Camden County Cultural and Heritage Commission, 1976.

Raible, Dennis G. *Down a Country Lane.* Camden, New Jersey: Camden County Historical Society, 1999.

Snyder, John P. *The Mapping of New Jersey.* New Brunswick, New Jersey: Rutgers University Press, 1973.

## Web Sites

Egg Harbor City: New Germany in New Jersey
http://oaklyn-nj.com/historical_society.htm
http://users.adelphia.net/~leuter/index.html
http://venus.atlantic.edu/amatol
http://web.mit.edu/smalpert/www/roads/spui/3x.html
http://www.aaca.org/
http://www.aclink.org/HISTORY/homepage.asp
http://www.atlantic-city-online.com/history/history.shtml
http://www.courierpostonline.com/125anniversary/publisher.html
http://www.drberlin.com/natbank
http://www.drpa.org/drpa/drpa_history.html
http://www.dvrbs.com
http://www.lonelyplanet.com/destinations/north_america/atlantic_city/history.htm
http://www.magnolia-nj.org/history/history.html
http://www.missamerica.org
http://www.nextination.com/longacoming/index.shtml
http://www.petermotthouse.org/contactus.html
http://www.phillyroads.com/crossings/benjamin-franklin
http://www.princetonantiques.com
http://www.state.nj.us/hangout/synopsis.htm
http://www.stratford.net
http://www.theflagship.net/hhhistorical/soc/about.html
http://www.theoutlaws.com/ghosts2.htm
http://www.townofhammonton.org/History.htm
http://www.two-lane.com/triviatimeline.html
http://www.westfieldnj.com/whs/history/Counties/CamdenCounty/collingswood.htm
http://www.westjerseyhistory.org/index.shtml